D0746468

IMAGES
of America

BUTLER COUNTY

THE BOSTON STUDIO COLLECTION

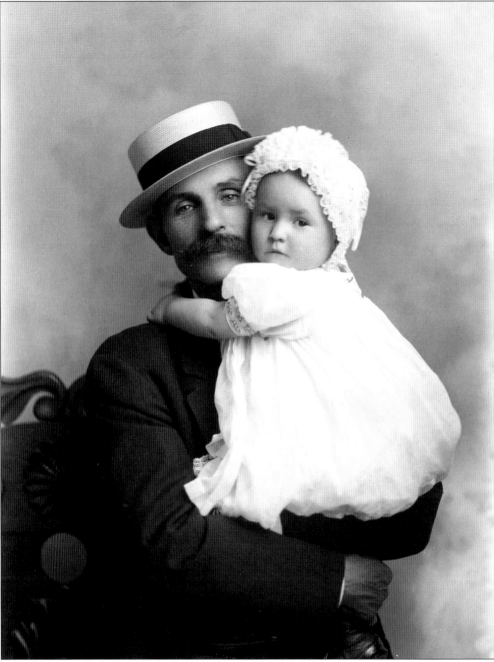

Joseph Carlisle of David City poses with his daughter Gertrude for a Boston Studio photograph in 1907. Straw boater hats were very popular for both men and women to wear in summer, being cool and lightweight. Carlisle's thick handlebar mustache was popular at this time period. The practical white lawn dress the baby is wearing is seen in many images, yet no two looked identical.

On the cover: Please see page 79. (The Boston Studio Project.)

IMAGES
of America

BUTLER COUNTY
THE BOSTON STUDIO COLLECTION

Enjoy!
Step Back in Time

Susan R. McLain

Susan R. McLain

ARCADIA
PUBLISHING

Copyright © 2009 by Susan R. McLain
ISBN 978-0-7385-6051-9

Published by Arcadia Publishing
Charleston SC, Chicago IL, Portsmouth NH, San Francisco CA

Printed in the United States of America

Library of Congress Catalog Card Number: 2008939832

For all general information contact Arcadia Publishing at:
Telephone 843-853-2070
Fax 843-853-0044
E-mail sales@arcadiapublishing.com
For customer service and orders:
Toll-Free 1-888-313-2665

Visit us on the Internet at www.arcadiapublishing.com

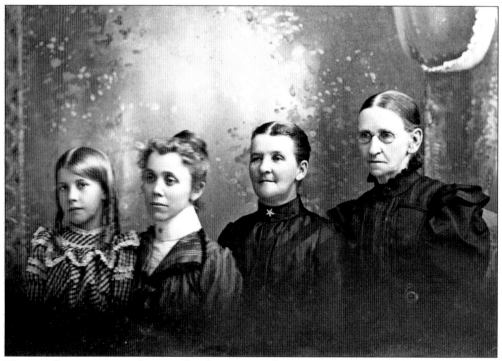

This is a four-generation photograph taken in 1900 by Harvey L. Boston of the Clara Zeilinger family of David City. Clara (second from left) is pictured with her daughter Maude; her mother, Hatty Brown; and her grandmother Lydia Thayer. Clara's clothing and hairstyle are the look for 1900, while the older women are wearing styles from an earlier time period. Maude's checked dress with lace trim was also very stylish at the time.

CONTENTS

ACKNOWLEDGMENTS

This book is the culmination of a desire to both preserve and to make available to others the artistic work of Butler County studio photographer Harvey L. Boston. At the same time, it is a desire to perpetuate the memory of the people who found themselves posing before Boston's camera.

It is easy to look at old photographs and be either amazed or amused at the clothing fashions of long ago. But beyond the costuming, it must be remembered that each Boston Studio portrait is otherwise a look at people who once lived and who wanted to make permanent an important moment in their lives so that others could share in their elation. Therefore, thanks is expressed to those who have given freely of their time and talent in order that the Boston Studio collection now can allow future generations to learn about past generations.

The following people made this book possible by their collaboration. Susan R. McLain readily agreed to serve as author and to provide her expertise on the subject of historic clothing. Jim Reisdorff originated the idea for the book and served as book editor.

Bonnie Luckey of the Boston Studio Project served as coordinator for the selection of images. Kenny Pohl, a Boston Studio Project volunteer, researched many of the details regarding the lives of the people depicted. Another volunteer, Jeanne Hain, also assisted with photographs. Other individuals or institutions were of assistance by their actions. The David City Area Foundation (now the Butler County Area Foundation) originally acquired the Boston negative collection from the McVay family and retained it for eventual preservation. Kay Schmid and the staff of the Hruska Memorial Public Library provided support leading to the housing of the Boston collection at the library. The board of the Thorpe, Inc., lent its support by assuming ownership of the collection. Tom Morgan made a monetary donation that provided initial funding for the Boston Studio Project. The Nebraska Committee for the Humanities, by its support of the author, has allowed her to expand her knowledge of former clothing fashions. As a blanket statement of thanks, assistance was provided by a number of persons who have donated clothing of historic value to the author in order to further enhance her understanding of vintage fashions. Similarly, a blanket statement of appreciation is extended to all those who have volunteered their time in preparing the Boston Studio negative collection for public use.

Every effort was made to correctly identify former customers of the Boston Studio as to their name and community (when available). However, insufficient or conflicting information was occasionally found when comparing Boston Studio records with other sources. In these instances, the most seemingly reliable source was used to identify the person (or persons). Any and all mistakes that may have occurred concerning the identity or personal details involving any person depicted in this book are the responsibility of the editor and the Boston Studio Project.

INTRODUCTION

Harvey L. Boston was born on January 27, 1871, in McCallsburg, Iowa, to John and Sarah Boston. He moved to Butler County in Nebraska with his parents in 1891. It was while living in the county seat town of David City that it is believed Boston worked for at least one photographic studio and learned the trade of professional photography before opening his own photo studio in 1893. For about the next 32 years, Harvey L. Boston operated the Boston Studio near the downtown business square in David City.

Following Harvey L. Boston's death on March 6, 1927, other Boston family members continued to operate the Boston Studio for many years. However, this book will feature only the photographic images that were created by Boston himself in the years between 1893 and 1927. This was a period of great change in both culture and technology for a midwestern and predominately agricultural region like Butler County. When Boston started his studio, personal cameras had not yet come into use and residents of a community went to a professional studio to have their portraits taken.

During the time period he was in business, Boston often photographed both the children and grandchildren of many of the pioneers of Butler County. These were the homesteaders, the merchants, the professional businessmen, the common laborers, and others who had helped the county to grow and develop since its initial settlement beginning in the 1860s. Boston otherwise photographed people who lived in Butler County just long enough to have their portrait taken and who then relocated to other parts of the country, their image as captured on either a glass-plate negative or nitrate film at the Boston Studio serving as one of the few reminders of their onetime presence here. In still other instances, Boston photographed people who lived elsewhere and whose sole connection to Butler County was through relatives or friends who lived here. A visit with said family or acquaintances often included a visit to the Boston Studio to have a portrait taken together.

In practicing his craft, Boston was known for having a skillful eye for detail. It is otherwise through Boston's photography that we are able to inspect and appreciate the clothing worn by Butler County residents of his day, from everyday styles to formal and special occasion costumes. Most people wore their finest clothing when having a portrait taken. When the Boston Studio opened in 1893, this was toward the end of the reign of Queen Victoria of England, who inspired morals and fashions during what was known as the Victorian era. (The period was also known as the Gay Nineties.) During this time period, the way a woman dressed was a reflection of her family's wealth and prosperity.

Hence, a woman usually took great pride in how she (and the rest of her family) looked. Details were very important during this time. This attention to detail was evident in fashion by the use of different laces, trims, and fabrics placed on every conceivable surface of garments. Also, the

hourglass silhouette became a fashion craze for women. Ultimately, the various fashions worn by the citizens of Butler County at the start of the 20th century can often provide a wealth of information about a person's life, even if very little biographical information about that person is otherwise known.

As mentioned, the time period in which Boston practiced his profession was a period of great cultural change in America that included women receiving the right to vote, the adoption of Prohibition, and World War I. All this would have a major impact on the fashion styles worn by women between the time Boston began his studio and the time he died. What the talented photographer thought of the extreme changes in women's fashions that he witnessed will never be known. However, the photographs he produced toward the end of his life show that his dedication to providing a quality image to a customer never faltered.

After Boston's death, many of the earliest photographs that he had taken suffered a fate that was frequently and similarly shared by other early photography studio collections around the country. With no real thought given by anyone as to its possible historic value, the Boston negative collection was alternately stored away in either a basement or attic. Subsequently, many of the earliest negatives either slowly faded away or shattered into pieces on account of their exposure to temperature extremes or moisture. Many Boston images, both those taken before 1900 and after, were lost in this manner. Fortunately, foresight would intervene to save the rest.

Boston family members sold the Boston Studio to the John and Fred McVay families of David City in 1973. It was then operated for a few more years by the McVays before closing. In 1979, when the business and studio building were sold at auction, the surviving Boston negatives and business ledgers were finally recognized for their historical merit. The collection was obtained by the David City Area Foundation, a civic endowment organization, and placed in storage. Finally, in 2003, the negatives were moved to the Hruska Memorial Public Library in David City, and a board was created to oversee their preservation. The following year, the Boston collection was given to the Thorpe, Inc., an organization otherwise dedicated to the restoration of the local opera house.

Currently, after about 10,000 hours of volunteer labor, the surviving Boston Studio negatives have been cleaned and organized. Additionally, information in the Boston business ledgers has been put into a database and placed on the Internet. More than 60,000 negative images are now maintained by what is called the Boston Studio Project.

Most of the images are portraits, but there are also photographs of businesses, sporting, and school events. Genealogists and historians from around the world can now visit the Boston Studio Web site at butlercountygallery.com.

This book departs from the usual format found in pictorials dealing with the history of a county, most of which largely depict structures or landscapes. It instead dwells on its greatest asset—its people. The following is a cross-sampling of portraits of early Butler County residents, some whose names and accomplishments are still recognized today. Others are known only from their patronage of the Boston Studio. In their own way, each was responsible for influencing the history of Butler County. To them credit is due. That includes Harvey L. Boston, for his skill at freezing images in time.

One

HARVEY L. BOSTON THE PHOTOGRAPHER

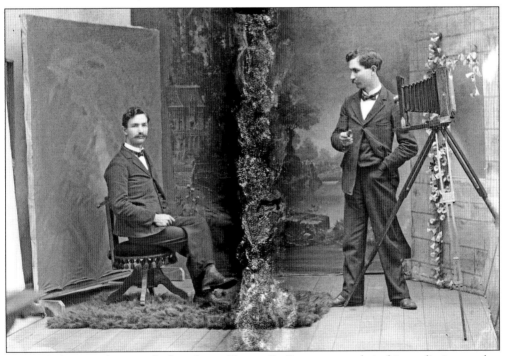

The only known photograph that shows Harvey L. Boston at work in his studio is one that shows Boston photographing himself. This split image, taken and put together at an unknown date, shows Boston both ready to trip the camera shutter and also posing in front of one of the backdrops commonly used for close-up portraits. Backdrops could then be purchased from the Montgomery Ward mail-order catalog for between $4 and $8.

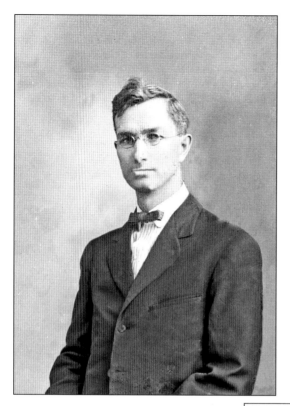

Harvey L. Boston (1871–1927) sat for his own portrait at an unknown date. He is wearing a three-button sack suit, typical business attire of the 1890s. The Boston Studio, originally located in a frame building near downtown David City, moved to a new brick building in June 1901. (This building is currently an attorney's office.) Over the years, Boston had several assistants in his studio. Some later went into the photography business for themselves in Nebraska and Kansas. Boston received many awards for excellent work at photography contests. He served for a time as vice president of the Nebraska State Photographic Association.

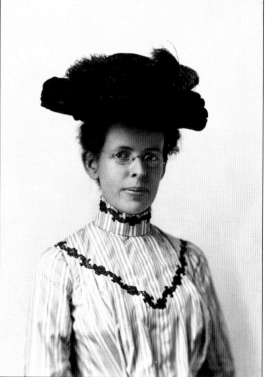

Margaret Boston (1870–1951) was a pioneer resident of David City. Born at Rock Bluffs, she was a member of the third David City High School graduating class. She married Harvey L. Boston on August 15, 1899. They had two daughters. Photographed by her husband, Margaret is wearing one of the big hats that were the fashion rage around 1907. An upstanding woman of the community, she was for years an active worker in the Women's Christian Temperance Union. Margaret continued to operate the Boston Studio after Harvey's death.

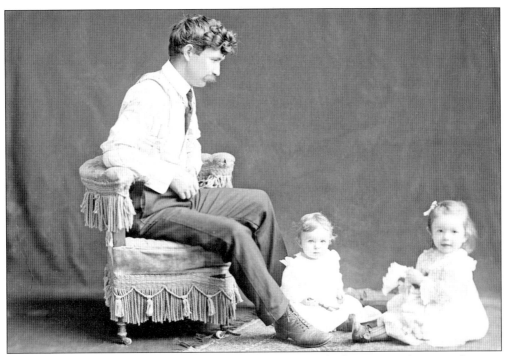

Harvey L. Boston used the techniques learned from his studio business to document his own family as well. Here, around 1902, he is pictured with his two young daughters, Edith (left) and Floy. As daughters of the local photographer, many images of them as children are found in the Boston Studio collection.

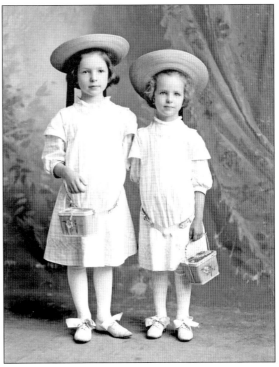

Edith (right) and Floy Boston grew up before their father's camera. Here they are wearing what was fashionable for little girls in 1909. Edith later assisted her father in the studio and following his death in 1927 assumed active management of the studio along with her mother. Edith married Anton Proskovec in 1941 and moved to Omaha but continued to commute to David City to operate the studio until Floy and her husband, A. C. "Prof" Hurlbert, took over the business in 1945.

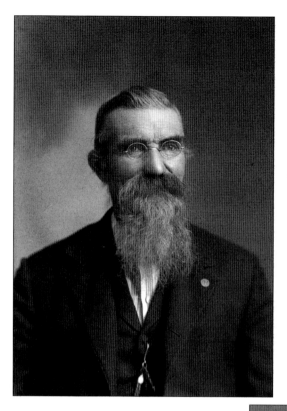

Harvey L. Boston's portrait-taking skills were extended to his own family. John A. Boston (1831–1913) was Harvey's father. Born in Pennsylvania, he served as a Union infantryman in the Civil War. He lived in Pennsylvania, Illinois, Iowa, and Rushville, Nebraska, before moving to David City in 1891. John farmed and ran a blacksmith shop while living in David City. From this 1901 portrait is noted a chain on which hung a pocket watch. Most men then had one.

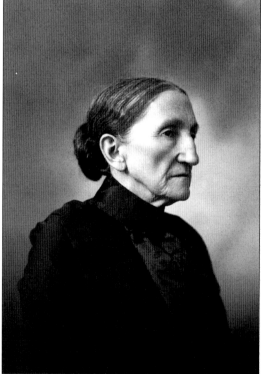

Sarah Durstine Boston (1833–1907) was Harvey's mother. A Pennsylvania native, she married John A. Boston in 1852. They were the parents of six children. Here Sarah is wearing a simple hairstyle in 1902, a time when younger women were wearing very full chignons. Her dark dress may signify a death in the family.

This group photograph of Sarah Durstine Boston, Harvey's mother, and Floy and Edith Boston, his daughters, may have been taken around 1907, shortly before Sarah died. Older women had a tendency to wear styles that reflected an earlier fashion. Here the grandmother is dressed in clothing from the early 1890s. The two girls are dressed in fashionable post-1900 clothing.

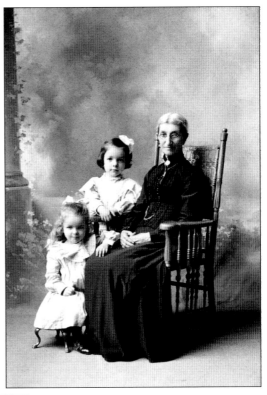

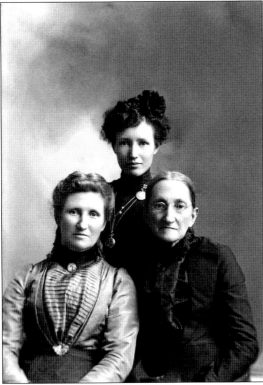

Harvey L. Boston on occasion took multiple-generation portraits. Again this included his own family. Here he poses his mother, Sarah; her daughter Mary Boston Freese; and Mary's daughter Sarah Freese, in late 1902. His mother is in dark clothing typical of older women. Mary wears a memory pin, while Sarah Freese has on a double chain, a watch, and locket. Mary was born in Butler County, Pennsylvania, and later came to Butler County, Nebraska.

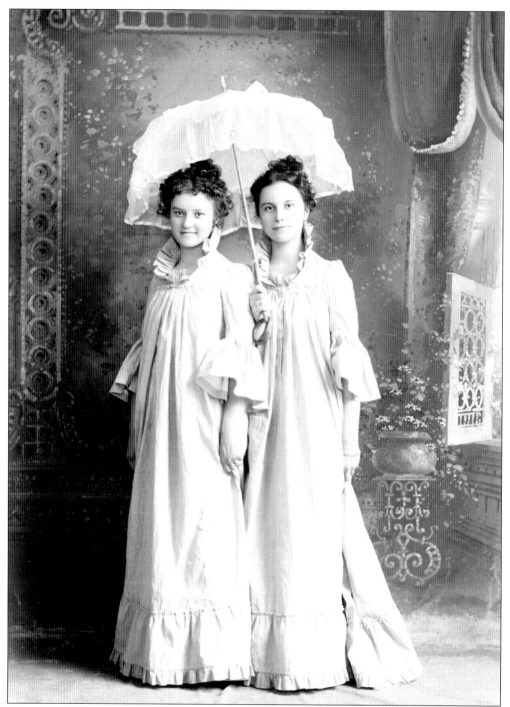

Harvey L. Boston photographed two of his nieces, Jessie and Marie Boston, in June 1901. Jessie was the daughter of Harvey's brother Orren. Marie was the adopted daughter of another brother, William. The two young women are in dressing gowns or wrappers that were worn in the privacy of their home without a corset. This was otherwise a popular maternity dress. The parasol adds playfulness to the picture.

Orren W. Boston was a brother to Harvey L. Boston. Here, in an 1897 portrait, Orren is pictured in a Civil War uniform that probably belonged to his father, who had served as a private in the Union army during the Civil War. Such would have been worn for parades and celebrations to honor those who served in that conflict. By 1920, Orren was living and farming in Florida.

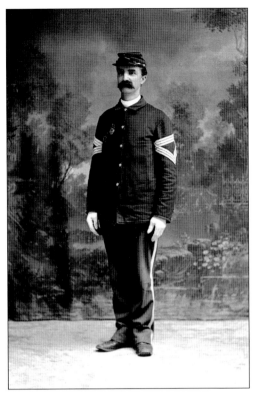

This is credited as being a Boston family photograph since the glass-plate negative for it was contained within a box marked for family images. There is no other identification provided. However, it would suggest that Harvey L. Boston had a sense of humor and that not all his photographs were serious.

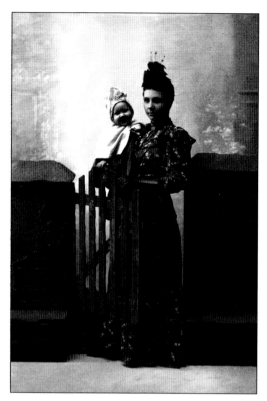

This is the oldest (known) surviving image from the Boston Studio collection and was taken just a few days after Harvey L. Boston had opened for business. Dated October 21, 1893, it shows Lettie Tilma holding her eight-month-old daughter, Hazel, at a fake household gate. Boston made props available to customers in order to make sittings appear more natural and interesting. Lettie's husband, Michael Tilma, operated a meat market and grocery store on the downtown square in David City.

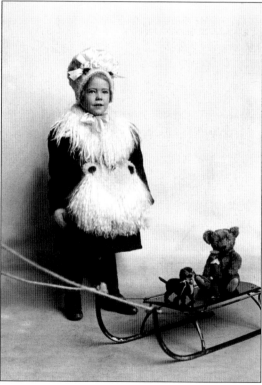

This image of four-year-old Rachel Elmore, taken in 1910, is an example of those Boston Studio customers who were not county residents. Rachel was born in India. Her parents, Wilbur and Maude Elmore, were missionaries for the Baptist Church, and her mother was listed as a lecturer for the church. The family, then living in Lincoln, likely had this portrait taken while visiting David City. Rachel looks like she stepped out of a Christmas postcard in her fur set made of Angora.

Two

EARLY DAVID CITY RESIDENTS

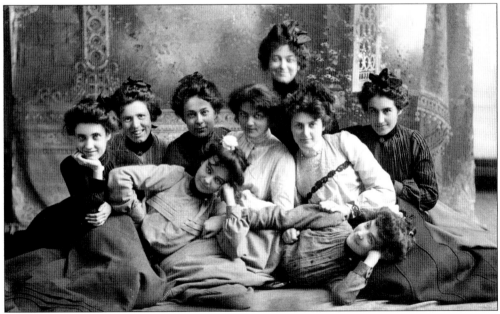

A Boston Studio business ledger for 1902 identifies this fun-loving group of young women as the David City Trimmers. Women at this time formed groups or clubs for fun and social activities. These ladies are dressed in all the latest: Gibson girl hair, high collars, long-sleeved bodices, and long skirts.

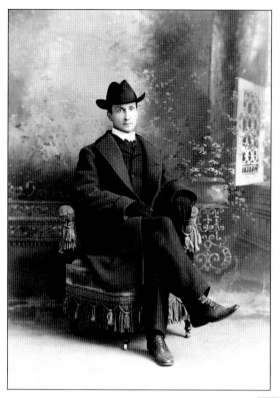

Edward Runyon is a good example of how businessmen dressed in the early 1900s. Business attire suits, with three front buttons, were typically worn with a detachable high collar, long-sleeved shirt, tie, and button-front slacks. Runyon came to Butler County in 1871. He worked as a railroad telegrapher for 12 years. He purchased the *People's Banner* at David City in 1913 and operated the newspaper for 30 years. The *People's Banner* later merged with the *Butler County Press* to form the county's current newspaper, the *Banner-Press*.

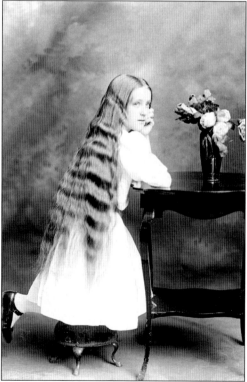

Having a full head of long tresses was a must for women in 1910. Young girls would often have their picture taken to show off their hair. Thirteen-year-old Lydia Runyon was the daughter of David City newspaper publisher Edward Runyon (see above) and his wife, Nellie.

In June 1900, 18-year-old Queene Hortense Snow was an example of the "era of opulence." Her hourglass look featured hip-hugging, full skirts with rows of ruffles and a train in the back. Parasols were costly and served a dual purpose: to protect the face and neck from suntanning and to show wealth and social status. Snow was a talented musician and performed often at the Thorpe Opera House in David City. She later married Henry Givens Cox, an Omaha musician (see below).

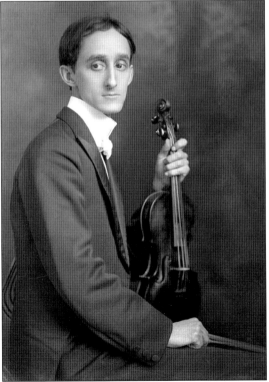

Henry Givens Cox, husband of Queene Hortense Snow (see above), was photographed at the Boston Studio in 1909. Like Queene, he was an accomplished musician and taught music in Omaha. He was also an early conductor of the Omaha Symphony. Henry and his wife endowed a scholarship given through the David City High School.

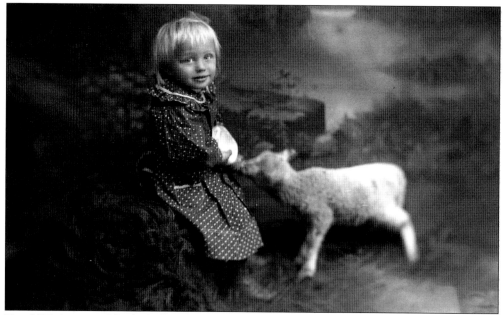

Harold Zeilinger and his little friend from 1909 illustrate the great job done by Harvey L. Boston in matching backdrops to the people and clothing. In this case, it made a country setting. Young boys wore dresses until age two to three, along with dark stockings and high-top shoes. The homespun dress was very practical for children to play in. Harold Zeilinger later farmed near Rising City and raised registered milking shorthorn cattle.

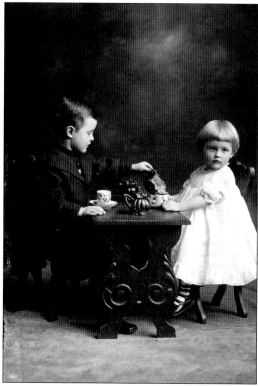

Three-year-old Richard C. and two-year-old Margaret A. Zeilinger, in 1910, are learning the proper etiquette of tea through play. Margaret later worked for the Barker Weeder Manufacturing Company in David City and played piano at a local theater during silent movies. In 1933, she married Ray Sabata, a David City attorney, and was active in women's organizations. Richard later operated Zeilinger Hardware in David City with his father, Richard W. Zeilinger (see page 23). Richard C. served as David City mayor from 1954 to 1958.

Gideon Gates is shown with the men's hairstyle fad of 1906, a center part. A native of Illinois, Gates came with his family to David City in 1876, where his father started one of the earliest bakeries in Nebraska. Gates was also an inventor and secured a patent on a candy-dispensing machine in 1902. The dispenser was in the shape of a man's head ("Happy Jap") and dispensed a stick of gum from his mouth.

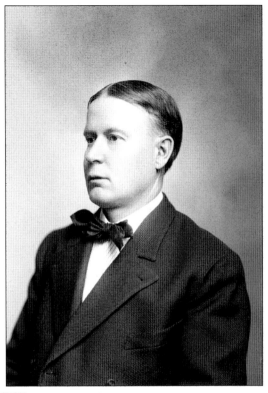

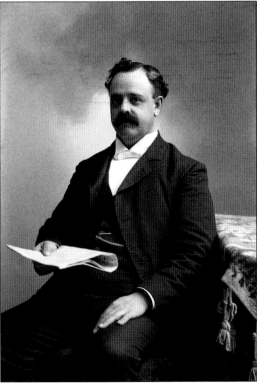

Rev. James Edwin Conner was a minister for the Baptist Church in David City in 1901. Pictured in his evening attire featuring a white bow tie, Reverend Conner was a distinguished man of the time. Born in New Jersey, he and his wife, Lillian, raised five children. The family moved to Clay County in Nebraska shortly after this photograph was taken. Reverend Conner died in 1906.

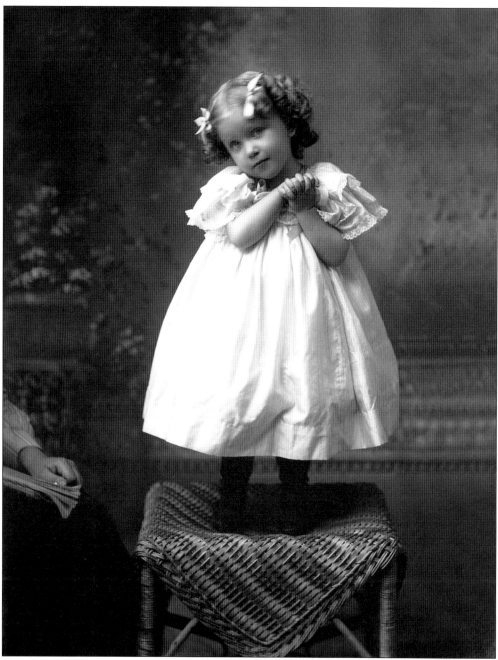

Three-year-old Ruth Etting was brought to the Boston Studio in 1900 for this portrait. Note that there are several petticoats underneath her white dress to create fullness. Even at a young age, Etting had a wonderful stage presence. Her mother died when she was five, and she spent her childhood living with her aunt and grandmother. Etting enjoyed singing in church and at school but never had any voice lessons. As an adult, she became a famous vaudeville singer in the 1920s and 1930s, first starring in the *Ziegfeld Follies*. She later performed on national radio and in several Hollywood movies. Her signature song was "Shine on Harvest Moon." Etting died while living at Colorado Springs, Colorado, in 1978.

Clyde Zeilinger was a prominent David City war veteran. He served in the Nebraska National Guard prior to enrolling in the World War I draft. He served on the Mexican border in 1916–1917 and then began training in the medical corps. He was captured by the German army while serving as a medic in France and held prisoner for two weeks. Here, in 1918, he poses in a standard World War I period uniform that includes a jacket, jodhpurs, spats, and a large hat. He was discharged from the army in May 1919.

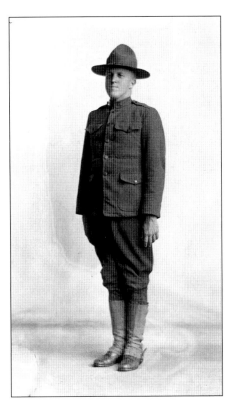

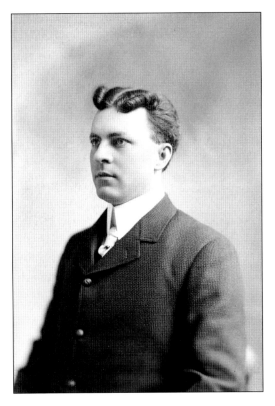

Richard W. Zeilinger was a partner with his brother, John F. Zeilinger, in the Zeilinger Brothers Hardware store in David City. A story from pioneer days tells how Richard was born in his family's dugout on the banks of Deer Creek in rural Butler County. Soon after his birth, a prairie fire swept the area where the family lived. Richard's cries in the night awakened his mother, who then saw the fire approaching. The family and their livestock were able to cross Deer Creek and escape the oncoming flames.

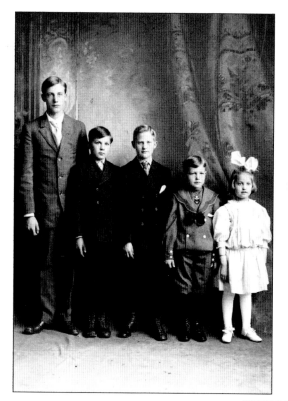

The children of George and Elise Schweser are posed oldest to youngest in 1908. It was in David City that German immigrant George Schweser originally established a Schweser's department store. The family firm of George Schweser's Sons later established a chain of Schweser's clothing stores. The chain is still in business. Pictured here (from left to right) are Harold, Carl, Robert, Fred, and Louise. Harold died in 1940 when he fell from the roof of the Schweser's store in Fremont.

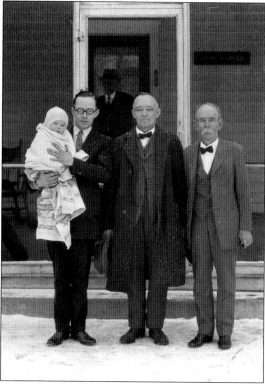

A four-generation photograph shows (from left to right) James, Morgan, Jack, and Philip Harper possibly standing in front of the Harper's dry goods store in David City in 1925. Philip was a Civil War veteran who came to David City in 1878 and was in the dry goods business with his brother John for more than 40 years. Large, round glasses were then very fashionable on account of Harold Lloyd, the silent movie actor from Burchard who first wore them in the movies.

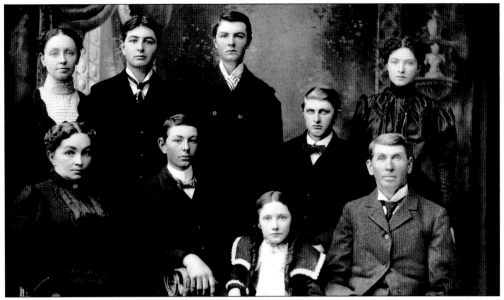

Michael Delaney, pictured with his wife, Katherine, and family in 1900, was an early Butler County homesteader who both worked the land and served the people. At various times he served as county superintendent of schools, member of the county board of supervisors, and justice of the peace and was twice elected (in 1888 and 1894) as a representative to the Nebraska state legislature. Pictured are (first row) Katherine, Charles, Mae, and Michael; (second row) Agnes, William, John, Michael, and Mary.

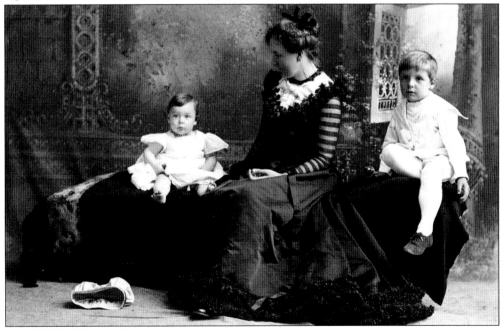

Madessa Wolfe is with her two young sons, Thomas Jr. (left) and Lionel, in 1902. Her husband, Thomas Wolfe, was president of the First National Bank of David City. The little Dutch boy cap lying on the floor gives the effect of a mother at home playing with her sons. Lionel died about two years after this portrait. Thomas Jr. served as U.S. assistant secretary of defense in 1956–1957.

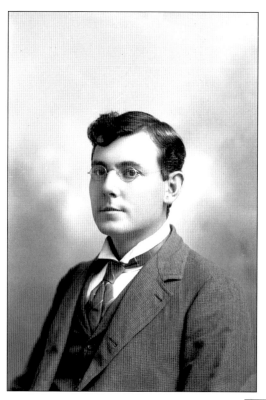

Dr. Simon C. Beede, pictured in 1900, was an Iowa native who began his medical practice at Surprise in 1891. Moving to David City in 1899, his practice grew rapidly, and within a few months, he and Dr. H. E. Burdick began a partnership. They started the David City Hospital in 1901 and erected a new hospital building five years later. The facility subsequently incorporated. Dr. Beede was also one of the 500 founders of the American College of Surgeons.

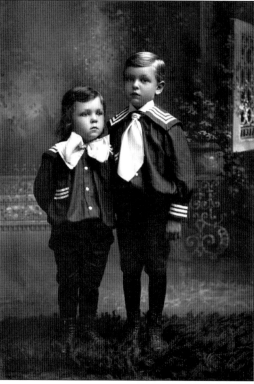

In 1900, Clark (right) and Ivan Beede were two of three children born to Dr. Simon and Millie Beede (above and on page 67). Dr. Beede moved to Surprise soon after graduating medical school, and both Clark and Ivan were born there. The family later moved to David City, where Dr. Beede practiced for more than 25 years. Clark pursued a career in medicine, was a World War I veteran, and worked at a hospital in Pittsburgh, Pennsylvania. Ivan is reported to have served in both world wars.

Eleven-year-old Helen Steele is dressed in a sporty winter outfit for this 1902 photograph taken with her dog. This generally served as a play outfit for a girl her age. According to the 1900 census, Helen's family was living in David City. Her father, Samuel Steele, was a lawyer. Her mother, Alice Steele, was postmaster.

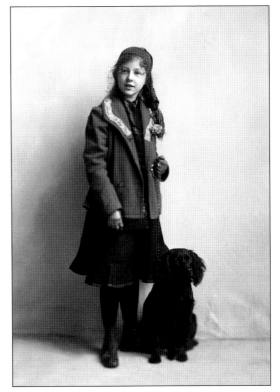

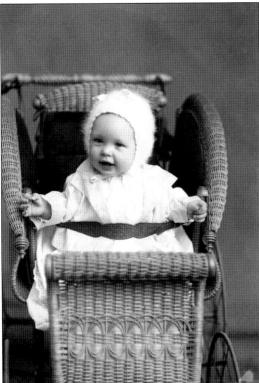

A wicker baby stroller like that holding Jeanette Smith was once popular for parading babies around town. Jeanette was born in 1904 to George and Gwendoline Smith. Her father was a minister. This is one of a series of 13 photographs that were taken once per month during Jeanette's first year. However, the exact date is not known.

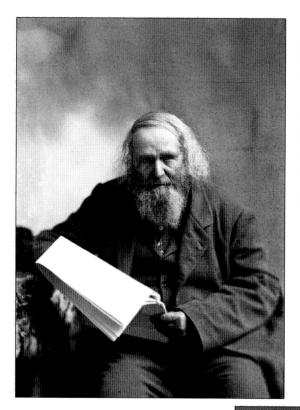

Harvey L. Boston captured John Merchant in true form as a homesteader, hardworking and practical. Merchant's three-piece wool suit would keep him warm in winter. There was no shirt, just his long underwear beneath his jacket. Merchant was a native of New York State. He traveled west and homesteaded in Center Township in 1870. Ninety-four years old in 1901, Merchant lived another two years after his portrait was taken.

Caroline Woodward appears to have enjoyed writing given her choice for a pose in 1901. As a fashionable mature woman, she is wearing a high-collar, two-piece dress. Hair combs were very popular for swept-up hair and could be purchased by mail order. A Wisconsin native, Woodward moved to David City in 1896. Three years after this photograph, her husband filed a homestead claim near Burwell, where they raised their adopted children.

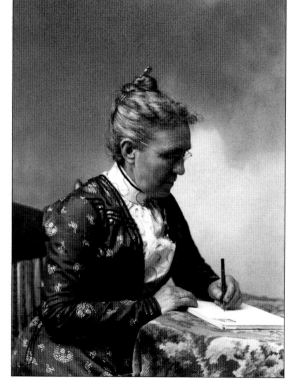

From 1898, Carrie Quade is pictured in a beautiful evening bodice, her hair pulled up and secured with an ornate hairpin. This was probably Quade's first updo for her hair. Her father was a David City miller. Quade frequently performed at the Thorpe Opera House in David City. She later married Ray Harris and moved to San Diego, where he was city attorney.

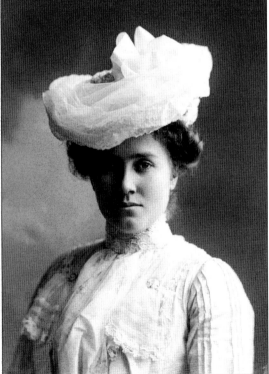

Anna Thomas wears a spring/summer outfit for this 1902 pose. The bodice top looks like two pieces but is only one; hooks and eyes are hidden under the pleats. Her beautiful matching hat could be found in the latest fashion magazines. Born Anna Reisdorff in Chicago, she married John Thomas shortly before this portrait. John operated Thomas' Tavern in David City. The establishment is now known for having been operated by four generations of the Thomas family.

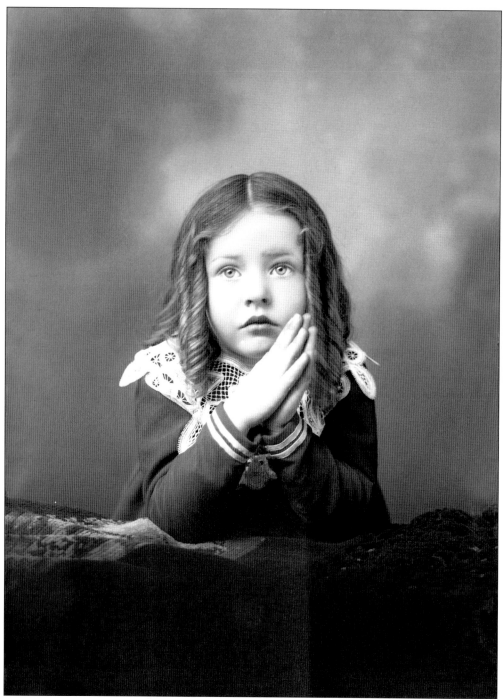

By 1900, ringlets symbolized feminine grace, while battenberg lace was very popular for collars and accenting dresses. Here five-year-old Mary Scott is made to look like an angel. Mary was born to Fred and Ella Scott. She never married and became an actress, living in Kearney for many years.

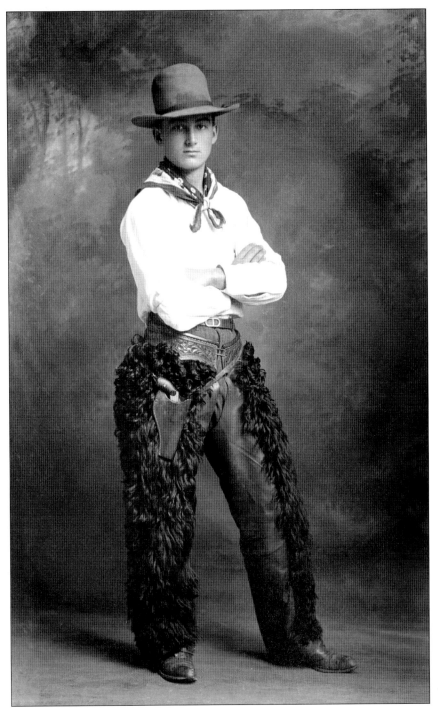

John J. Elliott wears a complete set of cowboy attire for this Boston photograph from September 1908. Elliott was born in Iowa around 1892, so he apparently was not around in the days of the Wild West. The outfit is also more like what people back East at the time believed cowboys wore every day. Elliott may have wanted a souvenir of his role in a local production at the Thorpe Opera House in David City.

This father-son picture from 1910 of William McGaffin Jr. and two-year-old James M. McGaffin shows that suits were worn every day. Small boys not only wore fashionable sailor outfits for their best dress but also for play. As part of a family known for its involvement in the print business, William Jr. was born in New York, the son of William McGaffin, a longtime Bellwood newspaper owner (see page 37). William Jr. operated a print shop in David City for a time.

Little Lucille Gates and Janka Deixtra, her family's Holland-born domestic servant, are depicted in a story time pose in 1907. Following college, Lucille Gates joined her parents (see page 21) in running the downtown Gates Bakery and Restaurant. After her father's death in 1928, Gates operated the bakery until it closed in 1944 due to World War II food shortages. She briefly moved to California to work in wartime aircraft production. She then returned to David City and was a partner in Morgan Insurance Agency with her nephew Merle Morgan for more than 25 years.

Benjamin Ogle Stoops's grandfather B. O. Perkins was one of the first residents of David City after the town was established in 1873. Here, in 1908, 18-year-old Stoops is still wearing the short pants typical of a younger man. He attended Wentworth Military Academy in Missouri and married in 1914. Stoops and his son moved back to David City after his wife died in 1920, and he worked in his father's clothing shop. In 1938, he opened the Stoops Men's Shop in South Pasadena, California, which he ran until 1956.

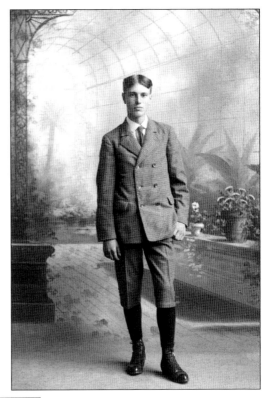

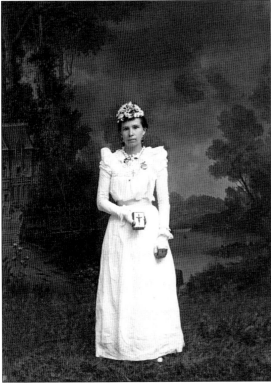

Harvey L. Boston used ornate backdrops during the Victorian era to emphasize the classical, ornate clothing of his clients. Here Annie Meysenburg wears an 1890-era white lawn dress. This was usually a woman's best spring and summer dress, often being worn for weddings, graduations, and religious functions. Annie Meysenburg's husband, Nicholas, served as a state representative in the Nebraska legislature in 1915 and 1917. He was running for a third term when he died in 1926.

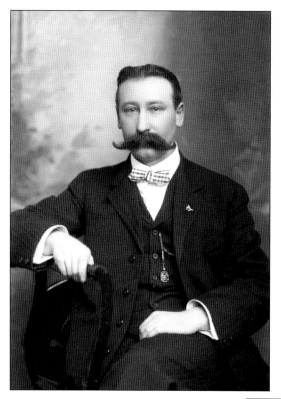

Alfred Etting was the father of Ruth Etting (see page 22). Pictured in 1908, Alfred is dressed like a successful businessman of the time, from his full head of hair parted down the middle to his handlebar mustache. He is wearing the classic three-piece suit and white starched shirt, while the checked bow tie adds a bit of flair.

Clara Hanner was born to Philip and Maranda Hanner, who farmed east of David City and raised a family of seven sons and one daughter. Pictured in 1900, Clara later taught in Butler County schools for 10 years. In 1921, she married Raymond Piers, who immigrated to Butler County from Belgium. They farmed near Garrison and raised one daughter. Raymond died in 1941, but Clara continued as a prominent farmer and livestock dealer until her death in 1964.

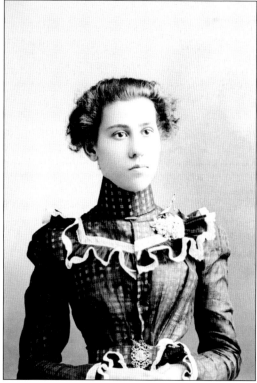

Three

PORTRAITS AROUND THE COUNTY

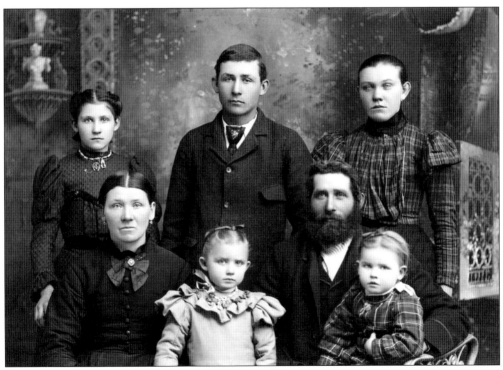

The August Herms family farmed in the vicinity of Ware, a small community with a store and post office that was located northwest of present-day Dwight. August and Louise Herms are pictured in 1900 with their five children: August, Emma, Anna, Bertha, and Ida. The parents and three older children had emigrated from Germany in 1893. August and Louise Herms are buried in the Ware Cemetery, the last remnant of the community.

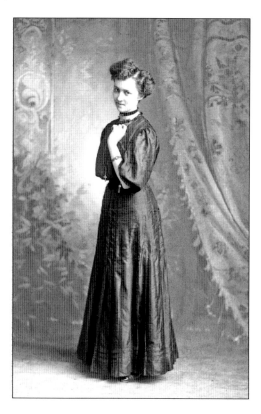

This image of Emma Vavrina of Abie shows that, by 1908, skirts were not as full as during the previous decade. However, gored skirts were still the fashion. Shirtwaists without high collars were used, but with an added choker around the neck. Sleeves were fuller, and the three-quarter-length sleeve was great for gloves and bracelets.

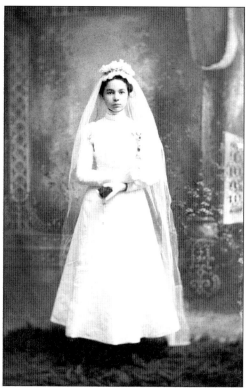

Mary Bock of Bellwood was 14 years old in 1900 when she posed in this wonderful white dress, which may have been for a religious event. Young girls wore the same style of dress as an adult, except that Bock's skirt was shorter in length than a woman at the time would wear. The veil could also have been used as a wedding veil.

William H. McGaffin of Bellwood poses with his son Wesley in 1910. A native of Ireland, William and his wife, Margery, had 14 children. They immigrated to Butler County, and William purchased the *Bellwood Gazette* newspaper in late 1885. He continued to publish the paper with the help of various family members until his death in 1927. The *Bellwood Gazette* was later purchased by the *Butler County Press*, which is now the *Banner-Press*.

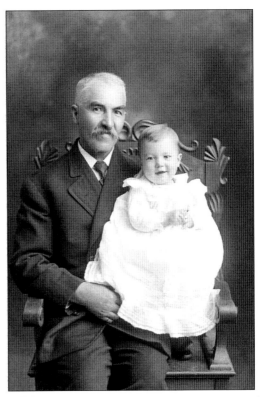

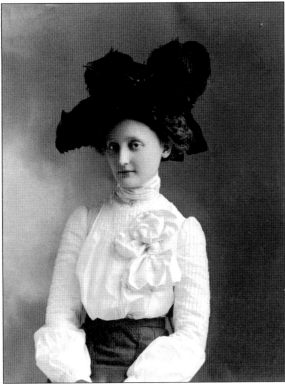

Bellwood resident Alta Wagener was in step with the Edwardian era, when large hats were a must. Some were so large it would take eight hatpins to hold them on. Her beautiful pin-tucked shirtwaist was also the style in 1903. An unusually large fabric bow accents her shirtwaist.

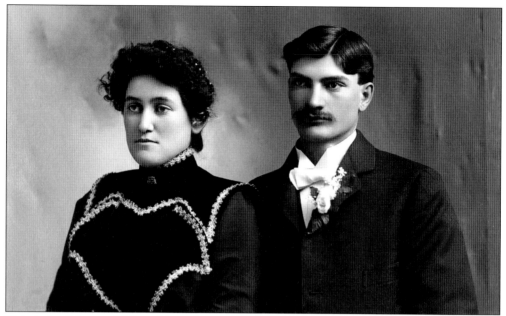

This is the February 1901 wedding photograph for Thomas and Josephine Bierle, address given as Bellwood. For a winter wedding it was not unusual to see dark clothes worn by the bride. People wore their best dress clothing for weddings, which they could then still wear afterward. Thomas was born in a hillside dugout on a farm his parents homesteaded southwest of David City. Josephine was born at Savannah, the former site of the first county seat of Butler County.

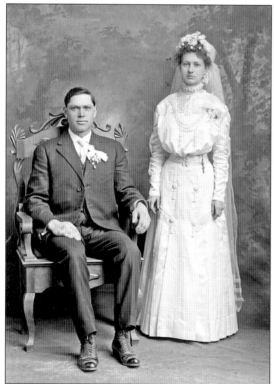

This wedding photograph was taken in 1910 of Benjamin and Katherine Homan of Bellwood. The bride's high-collared, elaborate bodice top and gored skirt combined to make a beautiful outfit, but one she could wear again. Many wedding dresses were worn after the wedding day for a Sunday best dress. The men would have worn their suit for years. The Homans, after farming and raising nine children, moved to David City where Ben operated the Homan Appliance store on David City's business square.

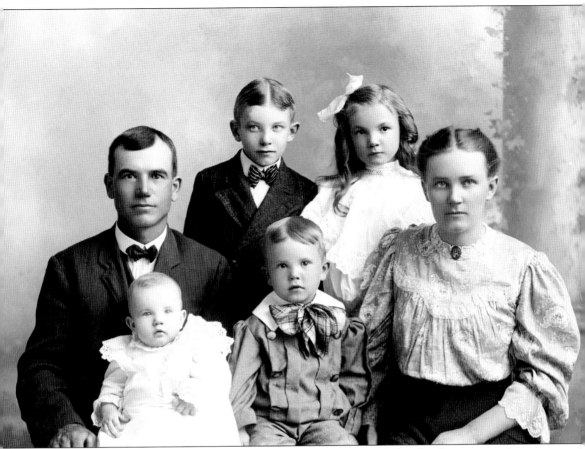

The John J. and Christine Meysenburg family of Bellwood had this family portrait taken in August 1906. Their family typified many of the descendants of early Butler County settlers. John was the son of Mr. and Mrs. P. N. Meysenburg, immigrants from the European country of Luxemburg. They were the first settlers in 1869 of what was known as the Luxemburg settlement, situated about five miles north of David City in the Platte River valley. The area also later became known as Marietta on account of the Catholic parochial grade and high school by that name that was conducted there. The Meysenburg children are, from left to right, (seated) Paul and Francis; (second row) Leo and Margaret.

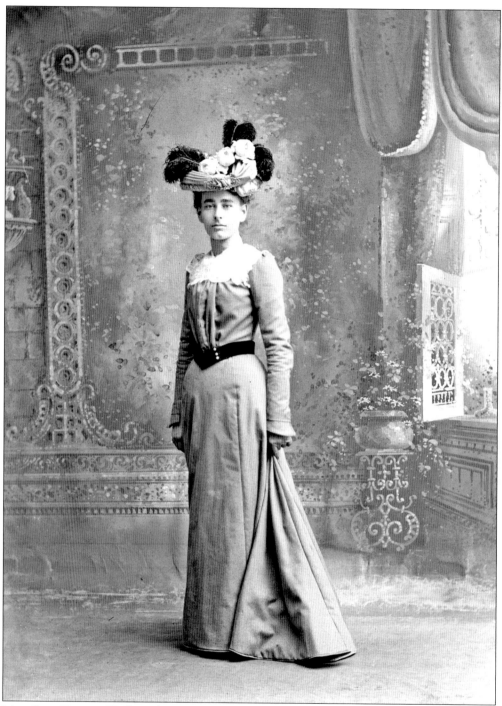

Mary Jane Harper of Bellwood wears a typical tailored or "visiting" costume for her 1901 studio shot. Women were then to look beautiful when they walked into a room and just as beautiful when they walked out. Clothes like this were frequently custom-made, but ready-made and mail-order apparel were then also becoming available. Coincidentally, Harper was listed in the 1900 census as being a dressmaker in Savannah Township.

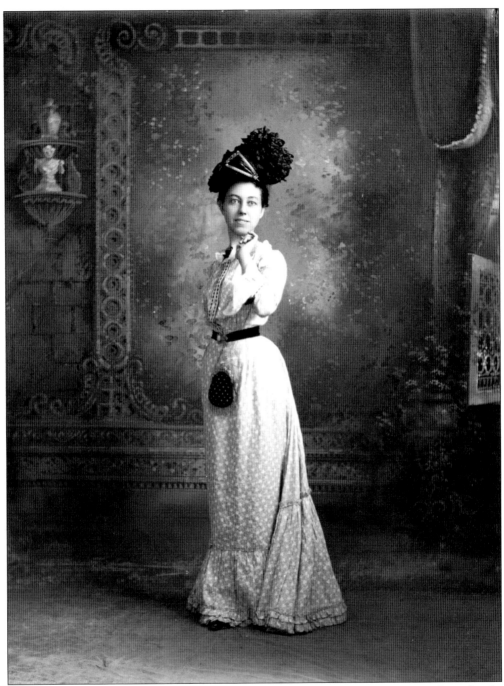

Bellwood resident Ella Gould was the daughter of George Armstrong, an early Nebraska territorial legislator and mayor of Omaha in the 1860s. Ella married George S. Gould in 1899. They lived at different times at Bellwood, where George was credited as building the first steam-powered elevator in the village. Ella's 1901 outfit, considered a typical visiting costume, is accented with a chantaline bag. This was used to hold calling cards, a few coins, a handkerchief, and smelling salts.

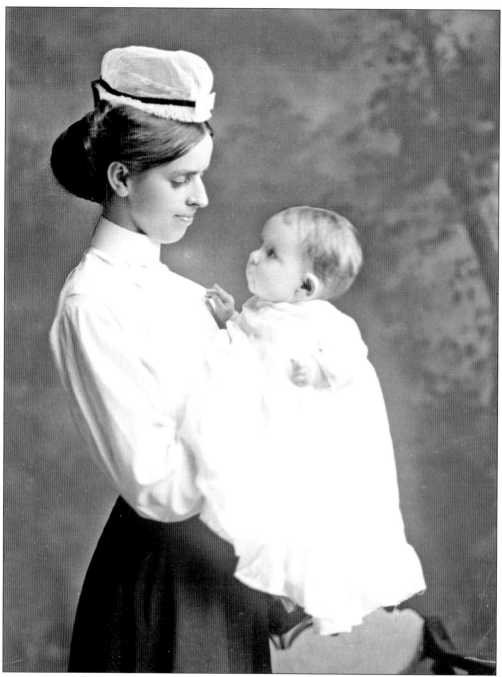

Amelia Meysenburg of Bellwood is pictured in 1910 with her second child, Caroline. A native of Austria, Amelia came to the United States at age nine to live with family friends in Columbus, Nebraska. When she was old enough to hire out, she worked as a maid in several different homes. She was working for Nick and Margaret Remakel near Bellwood when Margaret's brother, Henry Meysenburg, came to visit. Henry and Amelia were married in 1907, and they had nine children. Amelia is dressed in a young nanny uniform featuring a white starched shirtwaist, dark skirt, and cap.

Inez Wilkins was a native of West Virginia but was living in Brainard in 1898. She was a teacher in Butler County for some time before returning to West Virginia to live. Here Wilkins is wearing a beautiful crocheted combination scarf and hood called a fascinator. They first appeared in fashion magazines in 1860 and stayed popular until about 1910. They were not only easy to make but also warm for winter wear.

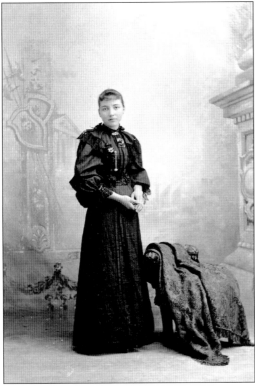

Rilla Brown of Brainard is in a dark, two-piece dress trimmed in lace. In 1895, such long, gored skirts were versatile and could be worn with other bodice tops. Her shirtwaist would have had boning sewn inside. Dark colors hid the dirt and could be dressed up or down.

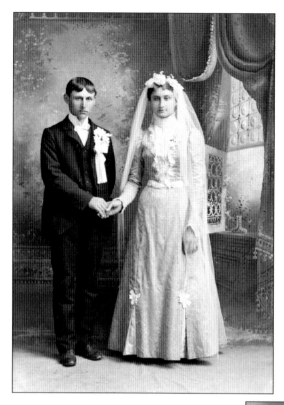

This 1902 wedding photograph shows John and Mary Coufal of Bruno. He grew up at Bruno, she at the nearby town of Abie. John worked as a store clerk in Bruno and later farmed near there. Note that John's collar is as high as his new bride's and at the time could be purchased for 10¢. Her two-piece dress could be worn again after the wedding. A Victorian era saying was "The truly thrifty woman can be wed, bred and dead in the same dress."

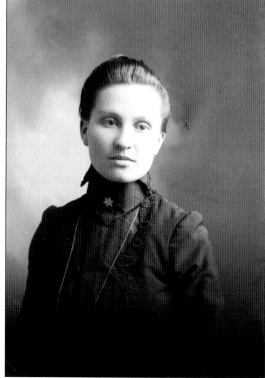

Agnes Zeman of Bruno, for her 1902 portrait, wears a very unusual collar that was not only high but also had a winged effect to it. Some of the collars then had boning inside to keep them up. Lace was added to give beautiful detail to the bodice top, with jewelry added to finish the look.

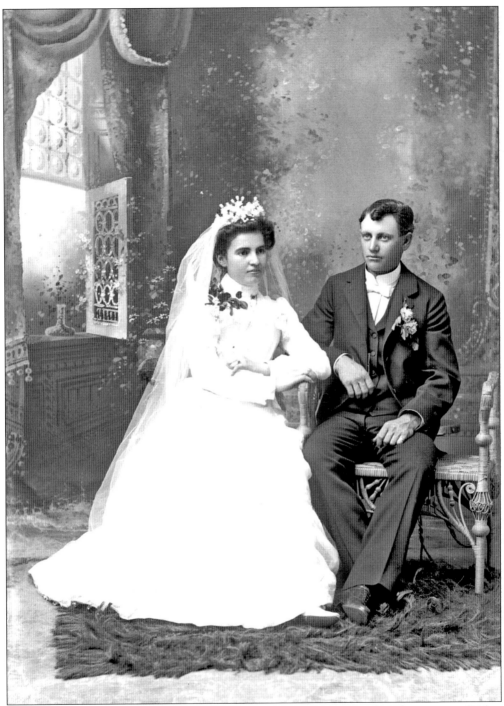

Louis and Caroline Kreizinger, following their marriage in 1901, farmed in the vicinity of Foley. This was a small community comprised of a grain elevator and a few residences along the Union Pacific Railroad tracks southwest of David City. For their wedding photograph, the Kreizingers pose with wicker, a fur rug, and an ornate backdrop used in a number of Boston images. Wedding veils like Caroline's were then often made of wax flowers, with added lace or lace netting.

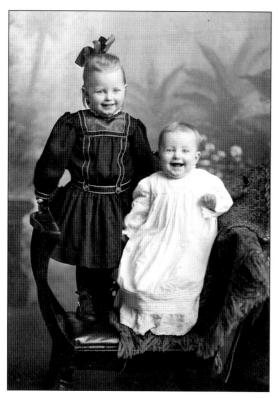

Alice and Homer Brown were the children of Abraham and Florence Brown of rural Garrison. This 1909 scene shows two-year-old Alice in a drop-waist dress with detailed bodice. One-year-old Homer wears a typical long white gown. The author would love to know what Harvey L. Boston did to get those beautiful smiles.

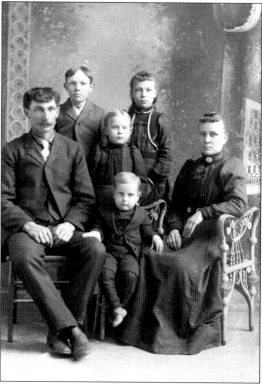

Charles and Ella Dallege of Garrison are pictured with four of their six children: Charles Jr. (seated), Ina (center), Howard, and Mabel (back). At this time, 1901, a lot of dark clothing is seen because laundering was difficult and dark clothing hid dirt. Also, children were often dressed like their parents. Little girls had dresses and hair similar to their mother, while the boys resembled their father.

Emil Folda was president of the Farmers and Merchants State Bank at Linwood when he had this portrait taken in 1901. Emil Folda had grown up in the area known as Huen in Colfax County. He started in the banking business as a bookkeeper and then assistant cashier at the First National Bank in David City before moving to Linwood. By 1920, he was serving as president of the Clarkson State Bank at Clarkson.

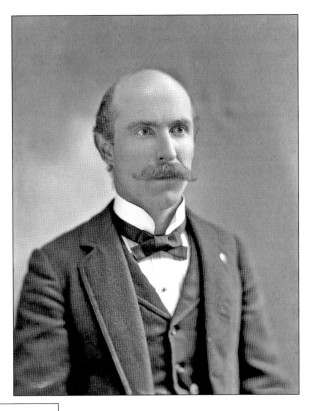

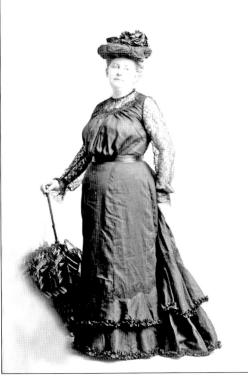

Rhoda Perkins Blair of Linwood taught school and worked in the David City post office before marrying William Blair in 1884. They lived on a farm near Edholm, a small community north of Octavia, before moving to Linwood. William was engaged in the grain business and later became postmaster. Seen here in 1902, hats like Rhoda's were sometimes made with fine horsehair and formed to just sit atop the head.

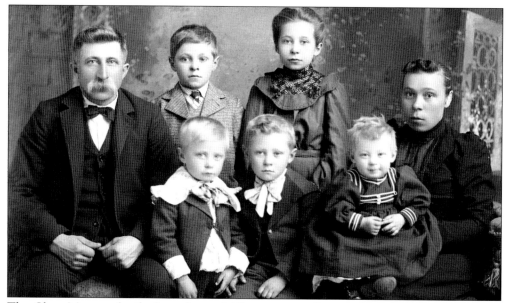

The Claus Martens family farmed near Millerton, a small community located southwest of David City along the Chicago and North Western Railway. Millerton was comprised of an elevator, a store, and a few residences. Claus and his wife, Margaretta, had both immigrated to America from Germany and married in this country. The couple is shown in 1902 with their five children: from left to right, Jacob, John, Henry (seated), Claus Jr., and Maggie (back). The family wears their Sunday best for their sitting.

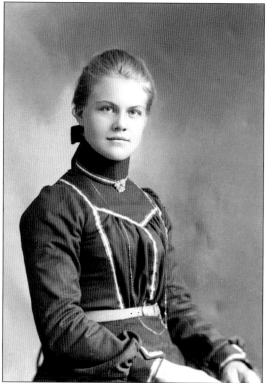

The family name of Piller was long associated with what is now the ghost town of Millerton. Freida Piller was born in Chicago to Reinhold and Minna Piller. Her parents moved to Butler County shortly after Freida was born and settled at Millerton, where her father operated a general store for many years. Freida is dressed as a 16-year-old girl would have in 1901. Her high collar, long tapered sleeves, and boned bodice top are detailed with simple contrasting trim. Brooches on the collar, together with the long chain necklace, were popular.

This wedding portrait of George and Amy Keller of Octavia was taken about a week after their actual wedding on March 18, 1909. The couple farmed near Octavia and raised three sons: Irvin, Dale, and Ardys. George and Amy would be among the Butler County parents required to make a great sacrifice for freedom's cause. Their son Ardys was killed while serving during World War II.

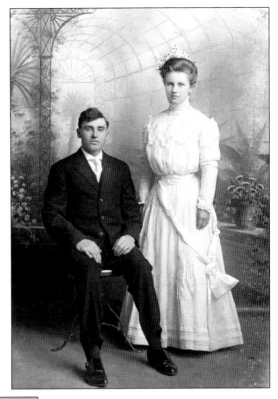

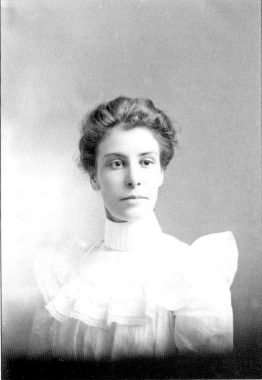

Amelia Shirk of Octavia, seen here in 1901, was the daughter of Oliver Shirk, the first minister of the Octavia Brethren Church. Following his death, Amelia's mother remarried and the family moved to Holt County. It was there that Amelia, then 13, spent the night in a snowdrift during the blizzard of 1888 as she and a companion rode home from school on horseback. Her companion and horse froze to death, but Amelia survived. Following the death of her stepfather, Amelia's family returned to Octavia where Amelia helped support the family by taking up dressmaking. Many a bride in Butler County wore a wedding dress made by "Aunt Millie," as she was fondly known.

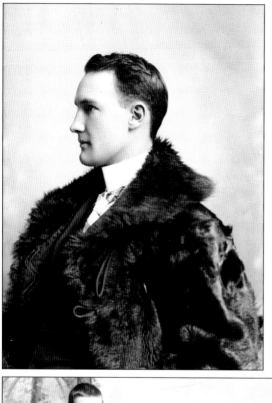

Jay Rising's grandparents were early immigrants to Butler County and the founders of Rising City. Sometime after this 1902 portrait, Rising moved to Kansas City, Missouri, and worked at a bank where he was associated with future U.S. president Harry S. Truman. Rising eventually became a vice president of Chase Manhattan Bank in New York City before retiring to Los Angeles. His family otherwise operated the Rising Ranch at Plattsmouth.

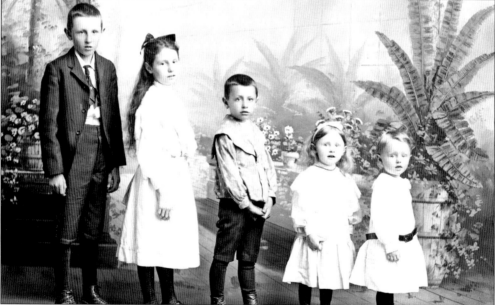

Hans, Gertrude, Ingward, Hildegard, and Werner Rathje (from left to right) were the oldest five children of German immigrants Herman and Helen Rathje of Rising City. Having the children in order of oldest to youngest shows how dress in 1907 was then different for each age. Hans is in a suit with short pants, Gertrude in a simple drop-waist dress with long hair and bow (she was not at an age yet to pull her hair up), and Ingward in a Russian suit. The younger children have on the dresses that both boys and girls of their age group wore.

Fifteen-year-old Emma Merscheim was the daughter of Christian and Kate Merscheim of Rising City. Her father ran a millinery shop, and her mother was a teacher. For young Emma, large bows for the hair went along with the full head of hair and large hats popular in 1906. Her two-piece summer dress made from cotton batiste is accentuated with a pearl choker around the neck.

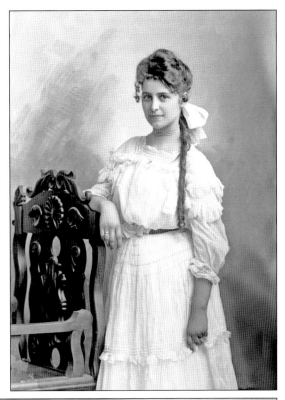

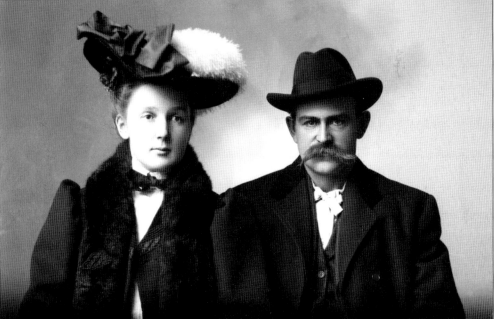

Walter and Flora Treadway farmed near Rising City where they raised eight children. Here the couple epitomized a fashionable couple for 1908: Walter in his dark fedora and overcoat, Flora in her large hat and coat with the added fur piece. Women were then also wearing white starched shirts with bow ties like the men. These outfits were warm and fashionable for winter.

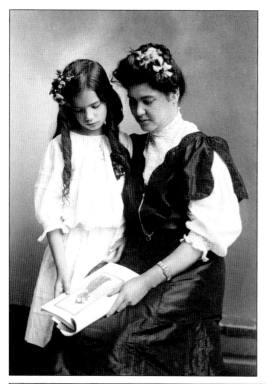

Theodosia Dolgner and her daughter, Nadine, then eight years old, lived near Rising City in 1907. Mother-daughter pictures of this period featured hairstyles of a soft, romantic look, with flowers added to the hair. Little girls were taught at a young age to look like ladies. The literature they are looking at appears to be a fashion magazine.

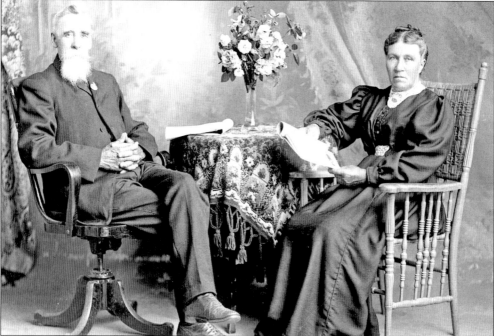

This 1909 scene shows George and Mary Rogers posed in a more relaxed, at-home setting for the more mature couple. George, a native of Illinois, and Mary, an immigrant from England, came to Butler County in 1878. Beginning in 1882, George and Mary Rogers moved to South Dakota for 15 years before returning to the Rising City area with their four children.

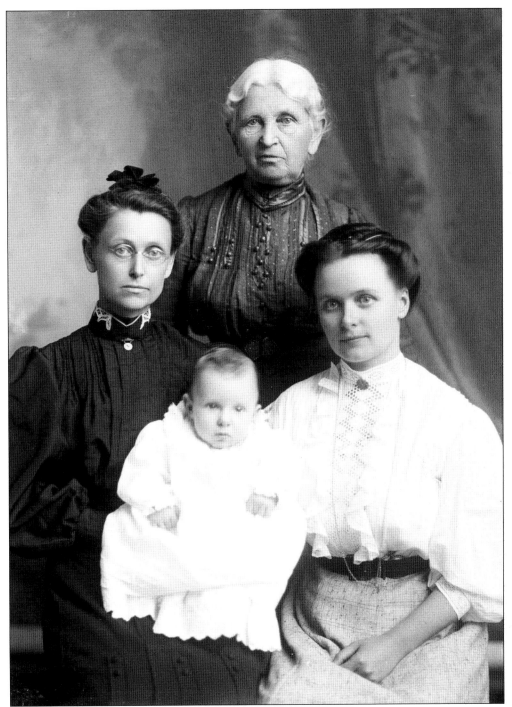

A four-generation picture of women from the Whitmore family of Surprise was taken in 1908. The oldest woman in the photograph is believed to be Emma Whitmore, who would have been great-grandmother to the infant. The village of Surprise once garnered national attention on account that residents of the community were reported on average to have the lowest death rate in the United States.

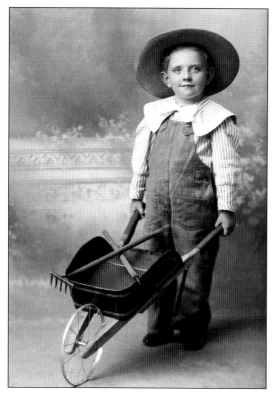

Five-year-old Kenneth Bentley, son of Milo and Maud Bentley of Surprise, presents a story book look in his large straw hat, brownie overalls, and striped shirt with the large Peter Pan collar and bow tie. This 1907 pose with a wheelbarrow seemingly foretold Kenneth's career. According to the 1920 and 1930 federal census, Kenneth lived in Oregon where he worked as a farm laborer.

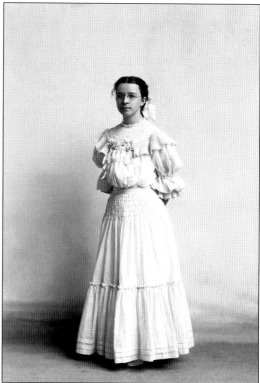

Eva Greenslit was born in Surprise, the daughter of Walter and Kate Greenslit. Eva is 14 years old in this 1906 picture, and her two-piece summer dress is substantial. The skirt alone would require 12 yards of material. Eva later married Leonard Anderson and moved to Chelon, Washington. There she was an educator, author, and legislator.

54

Five-year-old Karl Klingemann of Ulysses is dressed in a sailor suit for his 1908 portrait. Sailor suits became a boy's standard wear when Queen Victoria dressed her son, Edward, in one for the royal yacht. They looked handsome and were practical. Karl, however, would be a landlubber during his life. He was born on his father William's homestead and lived there until his death in 1957.

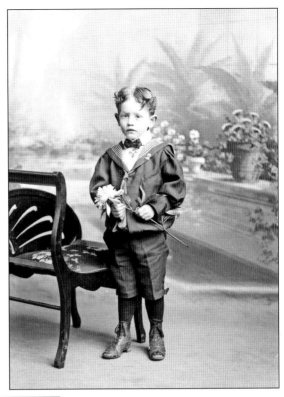

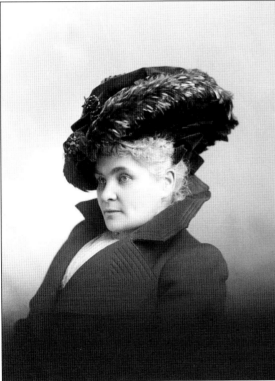

Lillie Andrews of rural Ulysses is wearing an ornate hat that, in 1901, would have cost about $5. Heavy black velvet was used in such hats, making them durable. Stitching added detail to the collar and lapel of her wool coat. Stand-up collars were then fashionable in outerwear.

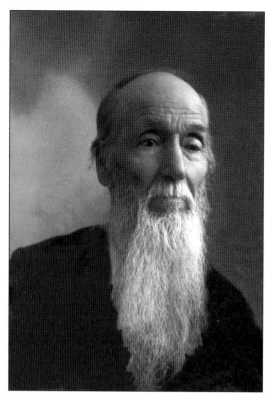

Elijah Sanders of Ulysses was 78 years old at the time of this 1904 photograph. He was born in Ohio in 1826 and later moved to Ulysses to live with his daughter and son-in-law, Samuel and Winnie Sleight. Elijah would live another 13 years after having his picture taken by Harvey L. Boston. His life story, which one might guess was as interesting as his long whiskers, is not readily known.

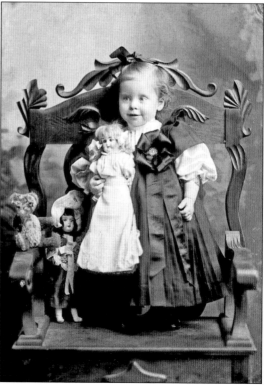

Minnie Weber was born in 1906 to George and Rosa Weber of Ulysses. Here 17-month-old Minnie looks like a doll herself with her full and long pleated jumper dress, with white under sleeves and high-collar shirt. Dolls were usually dressed in the fashion styles of the day. Minnie's adult life was spent away from Butler County. She died in San Diego in March 1940.

Four

ELEGANT LADIES

Women often
requested that they be
photographed with a
relative or close friend,
rather than alone,
and Harvey L. Boston
took many group or
duet photographs.
Here Mattie Bruner
and another woman,
who may possibly
be Tannie Miller,
were photographed
together in 1901.
Their caplets, with
high-standing collars,
were a great way to
change the look of a
dress and add warmth.
Feather-trimmed
hats, capes, purses,
and bodices were
highly sought-after
accessories of the day.

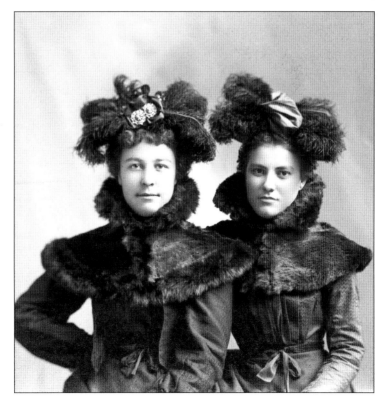

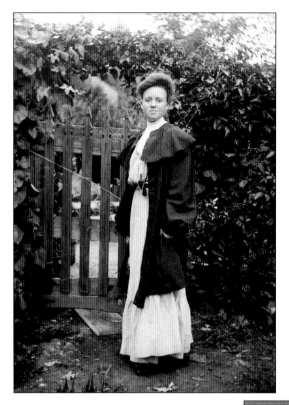

No studio prop was needed for Ida Dworak in this *c.* 1900 portrait. An actual garden gate was used instead. Ida appears beautiful in her simple shirtwaist and skirt, plus lightweight duster coat with large collar. She looks as if she were going for a late summer or early fall outing. Born at Cascade, Iowa, in 1875, Ida married Edward J. Dworak, a local banker, and spent her entire life in David City.

Addie Bell was born at Shelby, Nebraska, and moved to Butler County with her parents some time prior to this 1900 view. Here Addie's two-toned colored bodice with ruching has an asymmetrical design that was seen in clothing at the beginning of the 20th century.

Rose Delaney was born in Iowa in 1879 but moved with her parents to Butler County shortly after she was born. The man's double-breasted suit she wears in this 1900 photograph takes on a woman's version on account of the tucked-in waist and from being very fitted to accent the hourglass figure.

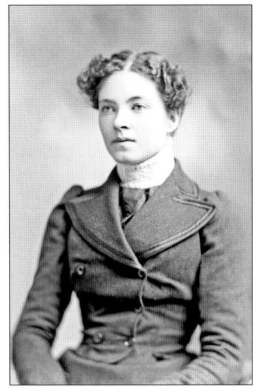

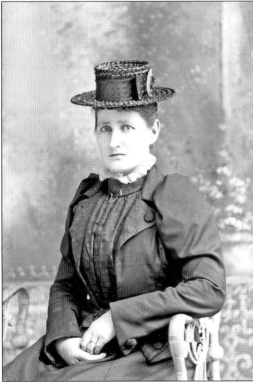

Viola Group, wife of Peter Group, of David City wears a dark straw boater hat with a high crown that was a very popular style of hat for sitting atop a woman's upswept hair. Her two-piece high-collar suit is practical and beautiful at the same time. This would have been a perfect outfit for any outdoor activity in 1900.

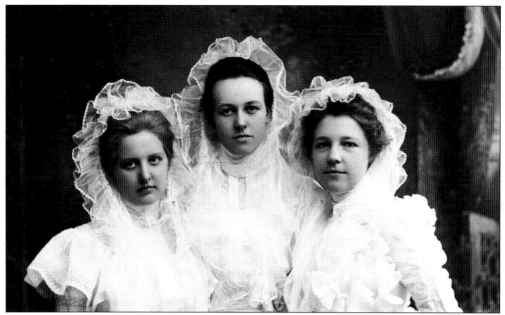

The three young ladies pictured here in 1900, from left to right, Queene Hortense Snow, Madge Evans, and Carrie Quade, are each individually described elsewhere in this book (see pages 19, 66, and 29, respectively). All three shared a love of song and/or theatrics. The three friends perhaps chose to be photographed together before adulthood took them in different directions. The sheer fascinators that match their dresses provide that dreamy, romantic look.

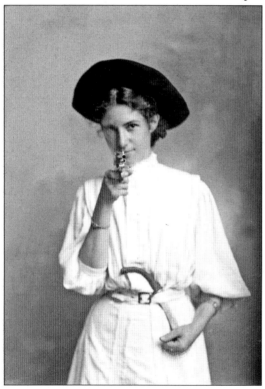

This unknown woman with a pistol epitomized the "new woman" look of the 1890s, as women were becoming more sports-minded and began to participate in more masculine activities. Annie Oakley, then one of the stars of Buffalo Bill's Wild West Show, was a very popular celebrity at this time. Many women and young girls emulated Oakley's ability to outshoot most men. This pose may well have been influenced by Oakley.

Barbara Kastner, from Linwood, and Anna Smith, address unknown, wear contrasting outfits reflecting their age and taste in styles. Smith is wearing a white lawn dress typical for Nebraska. Kastner, as a more mature woman, chose a dark-colored dress. Dark clothing hid dirt while white clothing had to be laundered. Both have their hair piled up and pinned in elegant coiffures that were in style in 1901.

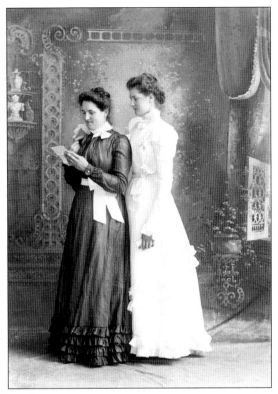

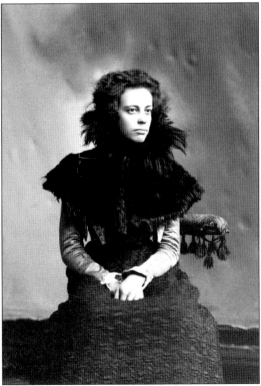

A beautifully detailed dark skirt of heavy fabric worn by Helen Decker in 1901 was perfect for winter wear. The short fur caplet that frames her face was also popular at the time. Women used fur in the winter for both warmth and to change the look of an outfit. The longer fur may have been monkey.

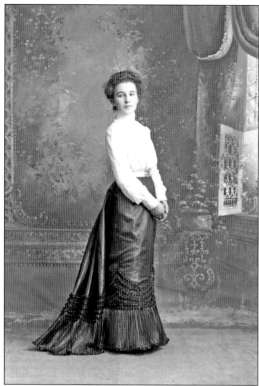

By the first part of the Edwardian era, women's skirts were to fit like wax at the hips and flow to the floor with a train in the back. Here in 1902, Fanny Tepley of David City is wearing a beautiful black satin skirt detailed with ruching and knife pleats. A dark skirt like this would have been very versatile.

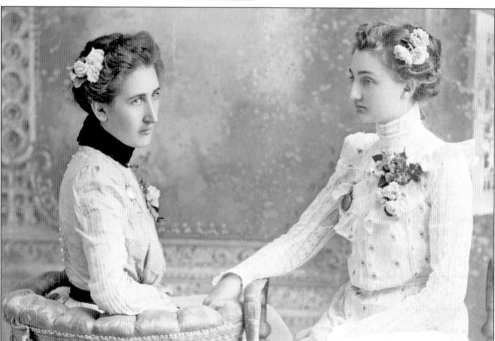

Agnes Hilger and older sister Christine Hilger of David City wear spring dresses with high collars for their studio sitting in June 1902. Small covered buttons often went down the back of such gowns. Flowers were not only worn as corsages but in the hair as well.

The plain white background in this 1902 image of Jessie Andrews makes her dark, two-piece traveling costume stand out. It includes a large stand-up collar that frames her face. Her large hat with marabou feathers is fashionable and sits on her Gibson girl hairstyle. Andrews, then 23, and her mother both worked as dressmakers in Butler County. Jessie possibly made this dress herself.

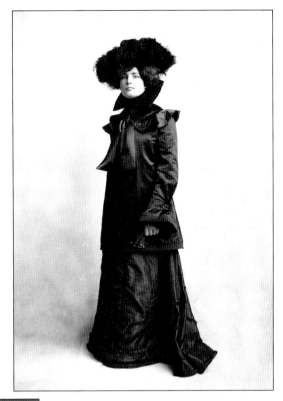

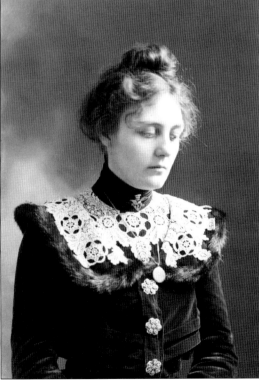

Jessie Colton's dress shows that durable, heavy velvet was practical as well as beautiful. It wore well and dirt could be rubbed off. Details on the dress, the fur trim, lace appliqué, and large decorative buttons, were a great way to change the look of a dress for the winter season. When this photograph was taken in 1902, Jessie was living with her husband, George Colton, and other family members in David City. The family had moved to Los Angeles by 1910.

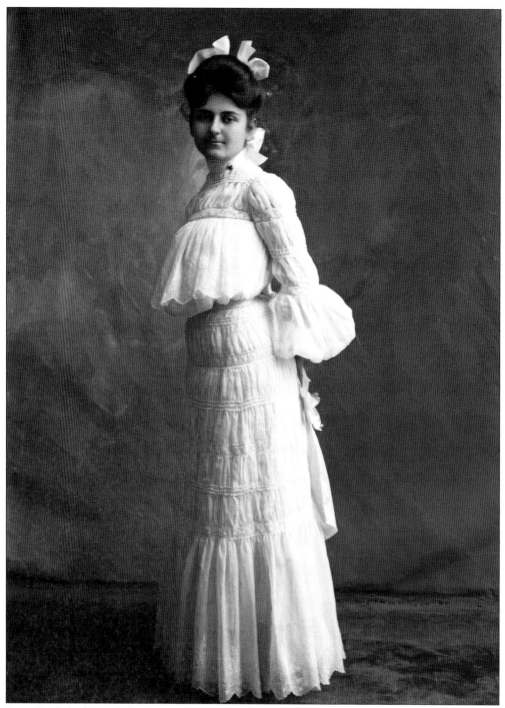

Rosa Styskal of David City, wanting to prove herself a young lady at age 18, has achieved the then-desired S silhouette in this 1903 portrait. This included the full pigeon front top, small waist, and full back. The full head of hair and large bow were the crowning touch to the style of dress and silhouette. Note the detail of the sleeves flowing with the skirt. Rosa later married Archie Gates of David City.

Belle Runyon is wearing a tailored suit that was in vogue by 1903. A white shirtwaist, belted gored skirt, and long jacket were perfect for motoring. Or she may have taken the train. According to the 1910 census, Belle and her husband, George Runyon, lived in Oak Creek Township where George was a railroad station agent. They later moved to South Dakota where George continued to work for the railroad for several decades.

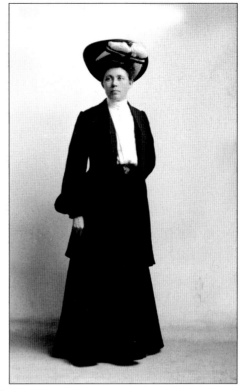

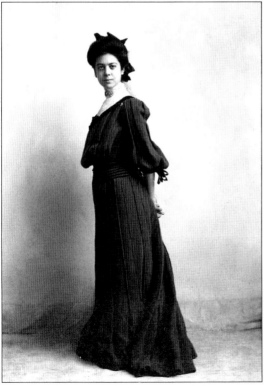

This full-figure portrait of Minnie Spelts really shows the fashion silhouette of the 1903 period. The full front gives the impression of comfort, but there would have been stays under the bodice top, down to her gored skirt with the full back. Large bows in the hair were opted in place of a large hat. Minnie's father, Lewis Spelts, was a grain merchant in David City.

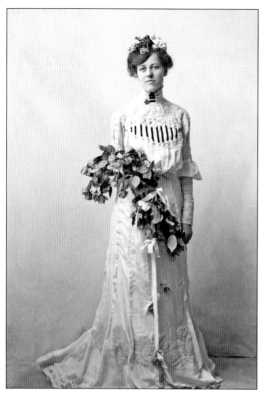

Madge Evans of David City shows that Nebraska women were as fashionable in 1903 as the ladies back East. The S silhouette is seen here, along with her pouter pigeon front and hip-hugging gored skirt. Her bouquet of flowers with the ribbon attached flows with her skirt. The bodice has black-and-white striped accent inserts. After graduating from David City High School, Evans moved to Lincoln and worked in the Lincoln City Library and Lincoln Book Store between 1912 and 1922. She then moved to Beatrice, Nebraska, and worked as city librarian until her retirement in 1952.

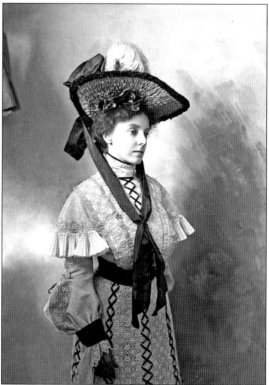

Hannah Gertrude Bell of David City exhibits a wonderful example of Edwardian extravagance in 1904. From the large decorated hat to the full dress with all the trimmings, detail was important, and there never was too much. Hannah, wife of Samuel James Bell, was a music teacher and mother of one daughter.

Permilia Beede was born in Illinois in 1867. She married Dr. Simon Beede (see page 26) in Surprise in 1893. They moved to David City in 1899, where Dr. Beede continued his medical practice. Here, in 1906, Permilia is dressed in a very soft and feminine two-piece dress. The sleeves are as detailed as the bodice top with the rows of ruffles. Three-quarter-length sleeves became very popular by 1906.

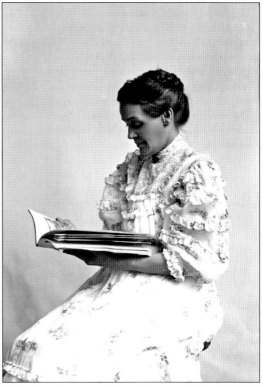

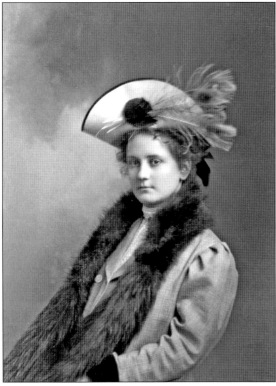

In the early 1900s, large hats were in style, and Bertha Neal of David City has on a great hat with peacock feathers. Laws were passed against the killing of birds for millinery use. Peacock and ostrich feathers were then used because they did not have to be killed to get their feathers. By coincidence, Bertha Neal's nickname (as listed in Boston's business ledgers) was "Birdie."

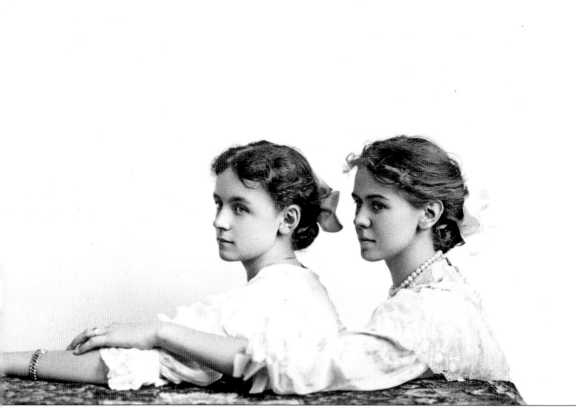

Jessie Green and Katie Hite, both about 17 years of age in 1906, were two sweet young ladies in their summer party dresses. The girls had reached an age when they would no longer wear their hair down, but up in a more ladylike manner. It was the rite of passage in a young woman's life when her hair was put up loosely with a bow to signify the coming event.

By 1907, the duster coat was popular for both men and women on account that more people were acquiring automobiles. They were a lightweight, loose-fitting coat made to keep dust off a person's other clothing as he or she rode in open-sided cars over dirt roads. Edith Hannegan of David City appears to have been caught up in the excitement of the automobile age. Gloves and traveling bags were otherwise a must for motoring.

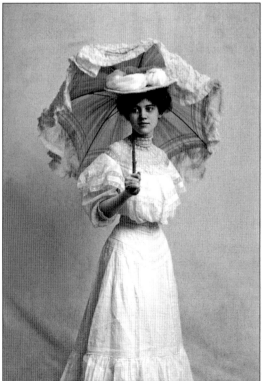

As a then-recent graduate of David City High School in the class of 1907, Margaret Swartz appears to have commemorated the occasion with a photograph of herself in a summer lingerie dress and hat. The full bodice top accents her tiny waist. Her large matching parasol was again both a status symbol and protection from the sun.

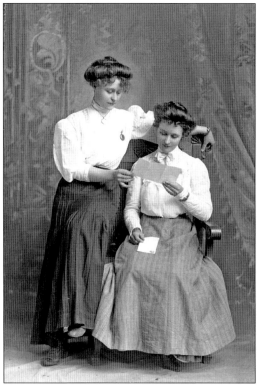

The U.S. Mail Service was an important means of communication with loved ones in 1909. Hence, it is not surprising that Eva Rugless and a woman believed to be her sister, Ethel, selected a pose showing them reading correspondence. White shirtwaists were the norm for young women to wear, along with pleated skirts. Their hairstyle with the full front could be achieved with the use of a hair rat as filler.

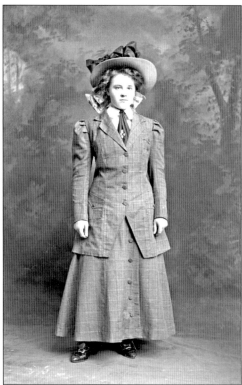

Agnes Rezek had been in the Unites States for about three years when she had this photograph taken in 1909. Born in Bohemia/Austria, Agnes and her parents followed her older sister in immigrating to America and came to Butler County. The suit worn by Agnes would have been worn for a sporting event or outing. The longer jacket was popular by this time, almost resembling a man's suit coat and tie. Dressing the part was just as important as the event.

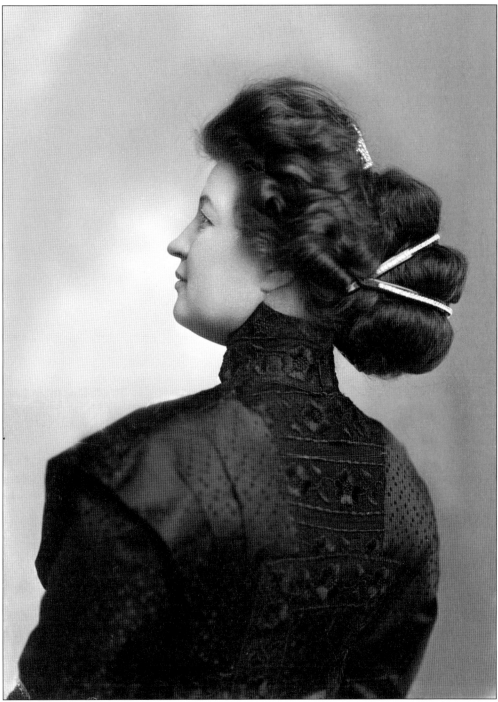

According to the 1910 census, Anna Kruebeck was single and working in David City as a servant/housekeeper for John Comber, a local minister. She was born in Ohio around 1880, the daughter of German immigrants. In this photograph, Anna Kruebeck chose to emphasize her crowning glory, a full and elaborate hairstyle. This is the Grecian style that was popular for evening and would have required a pompadour frame or a wig to achieve the look.

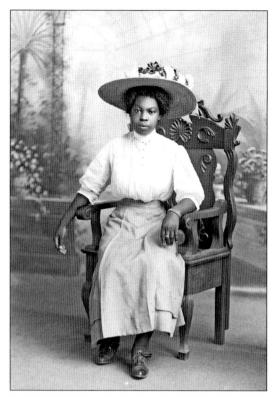

Marguerita Powell in 1909 is wearing a sportier look for outdoor activities with her shorter skirt. Her large straw hat was fashionable but also protected her face and neck from the sun. As an African American, Marguerita Powell was among only a few members of minority groups living in Butler County in the Boston Studio era who had portraits taken. According to the 1910 census, Marguerita was living in David City with her mother, Clara, who worked as a cook at a hotel.

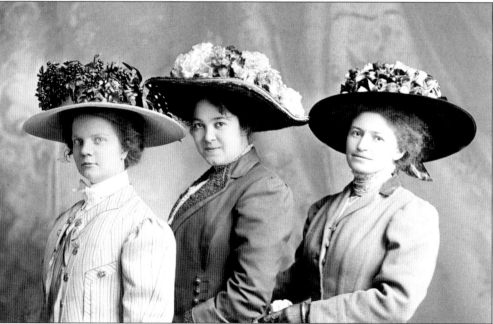

Mabel Cram of David City, along with two unidentified friends, shows that hats had become very large by 1910. They were decorated with lots and lots of flowers. With each season, the hats could be remade to a new look, and those seen here could have been their Easter hats. This holiday was the perfect time to show off new hats.

Addie Bigger (right) was a schoolteacher who lived with Rita Runyon and her parents in David City at the time this photograph was taken in July 1910. Here both Addie and Rita have on elegant automobile coats for riding in a tin lizzie. Several large hatpins were likely used to hold their hats on during a ride in an open-sided car.

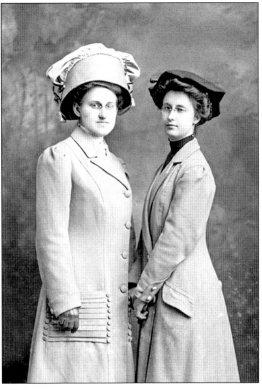

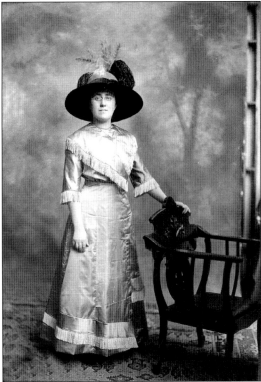

The skirt worn by Cassie Eberly of David City, around 1910, had more of an asymmetrical design than during earlier years. The dress looks like it was made from a curtain, and this was not unusual. Things were made and reused. Her very large hat with lots of feathers, bow, and veiling was known as "the Merry Widow hat." The name originated with a headpiece that actress Lily Elsie wore in a popular musical comedy of the time called *The Merry Widow.*

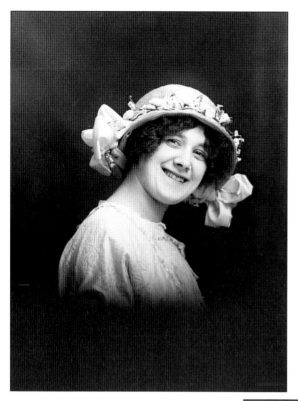

Hazel Walker's portrait from 1914 is an example of the dramatic changes then taking place in women's fashions. Her hat was small, round, head hugging, and a forerunner to the cloche hat of the 1920s. This new style came out around World War I. Hairstyles began to change, and girls no longer wore their hair up on the head but rather down around their neck.

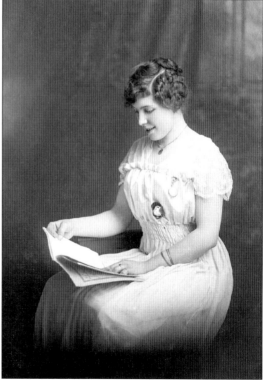

By 1915, the permanent wave was available in beauty shops, and women wanted the new wavy hair style. In photographs such as this one of Nellie Lanspa, one starts to see a more relaxed look in women's dresses, with looser waistlines and lower necklines. Clothing also became plainer during the years of World War I. Nellie married Adolph Kuhnel in 1919, and they farmed near Shelby, Nebraska.

By 1918, women's skirts were six to eight inches off the floor. Twenty-one-year-old Vernis Riha of David City exemplifies the style. There is almost a military look to her dress, with the sailor collar being very popular. Again, the wavy hair is pulled down around the neck. Clothing hooks with snaps on the sides of dresses were becoming common.

Sixteen-year-old Mildred Sypal of Brainard sports a one-piece dress called a frock in this 1920 image. The boat neckline was then popular. During the early years of the 1920s, it was fashionable for women to wear their long hair coiled over their ears to look like earphones. A less-complimentary name for the style was "cootie garages."

No more corsets! Thanks to World War I, the metal in women's corsets was used for the war effort. Thus, dress styles became more practical. Hair was also simpler and made to look shorter. Among those sporting this look in 1920 were Ludmilla and Rosa Cermak. They were sisters who grew up on a farm in Center Township.

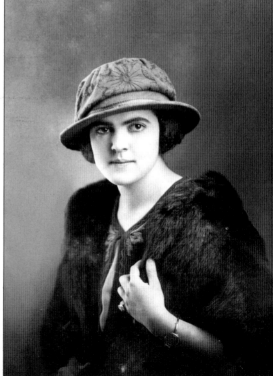

Dalyce Hull's father, Frank Hull, owned and operated a barbershop in David City at about the time of this 1920 portrait. Dalyce, then 19, wore her own hair to look short and to match her small, round hat. Many such hats were made from felt. Headpieces like this were made for the girl on the go and for driving her own car.

Henrietta (Lanspa) Miller was a modern Butler County bride for 1926. She has a head-hugging cloche veil made of fine net lace. Her dress is made of similar fabric. Brides then carried large bouquets, with sometimes as many as four dozen roses. Pearl necklaces were a standard piece of jewelry at the time.

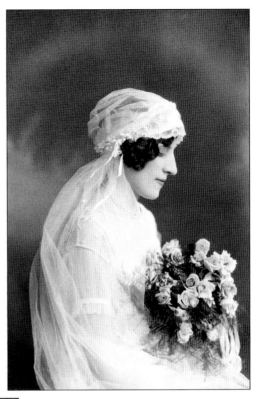

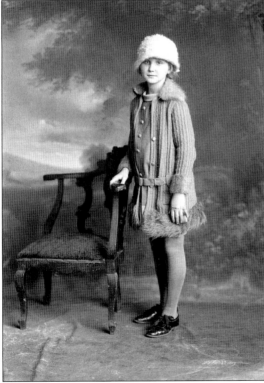

Fern Doty was fashionable in her drop-waist sweater dress and head-hugging cloche hat. Sweaters were the rage of 1926 and were being worn then by men, women, and children. Silver and mesh vanity bags like the one Fern Doty is holding were being carried by women and girls of the time. Doty's stepfather owned a fur farm in Butler County.

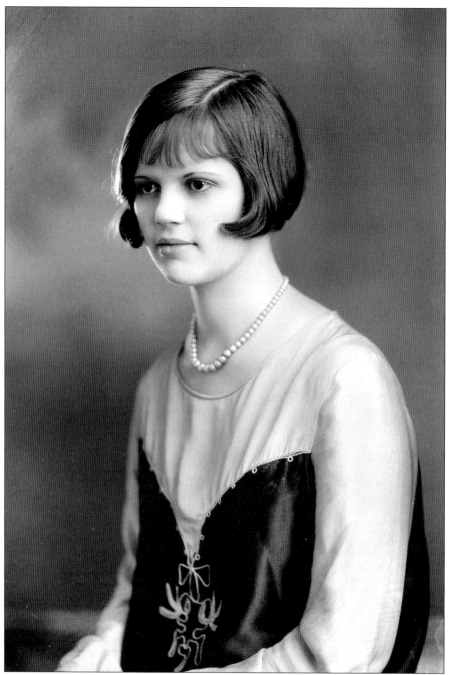

This 1926 view of 18-year-old Frances Bittner, the daughter of Summit Township farmer Art Bittner, is representative of the great change in women's fashions that Harvey L. Boston witnessed during his 32-year career in studio photography. Frances wears a modern, streamlined, and slender dress void of all the excess fabric of previous decades. She was the picture of a flapper girl. (This term came to describe a teenage girl at a time when it was fashionable for a girl not to buckle her galoshes. The buckles would then flap as she walked down the street, hence the term *flapper*.)

Five

CHILDREN OF
BUTLER COUNTY

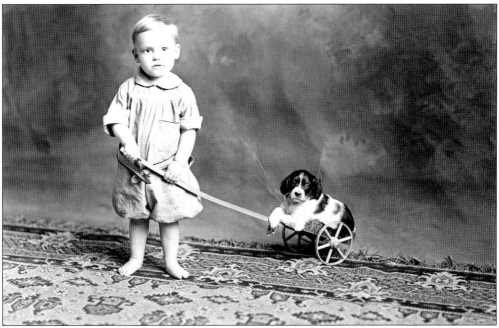

Some of Harvey L. Boston's business ledgers are unfortunately missing. Therefore, the identities of some of Boston's subjects, like this young boy with a puppy around 1911–1913, are unknown. One-piece rompers like what the boy is wearing first originated in France at the start of the 20th century. These were the first true playsuits. Designed with boys in mind, rompers took the place of dresses that boys were then wearing.

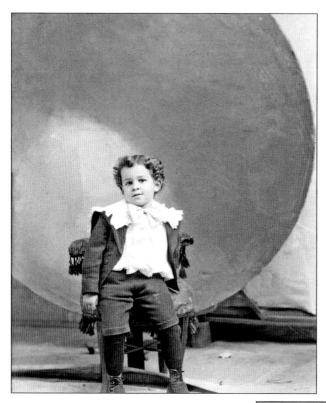

Frank G. Gates is pictured wearing the big fad for children in 1898: the Fauntleroy suit. It was named after "Little Lord Fauntleroy," a fictional character created by Francis Hodgson Burnett. The frilly blouse and short jacket were a popular outfit for many a young boy at the time. Frank's father, Frank W. Gates of David City, worked as a traveling salesman.

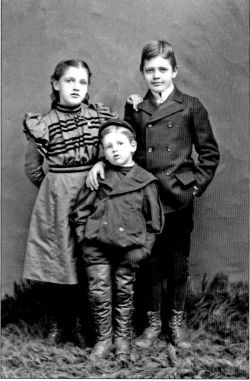

Fay, Garth, and Lyle Osterhout were the grandchildren of Judge George Washington Osterhout, one of the earliest settlers of Butler County. Their father, Frank Osterhout, was a lumberman in David City. Here in 1898, Fay is wearing a two-piece dress, similar to fashions worn by adult women. The boys are dressed in double-breasted jackets, short pants, and high-top shoes. Lyle is wearing a starched white shirt underneath his jacket.

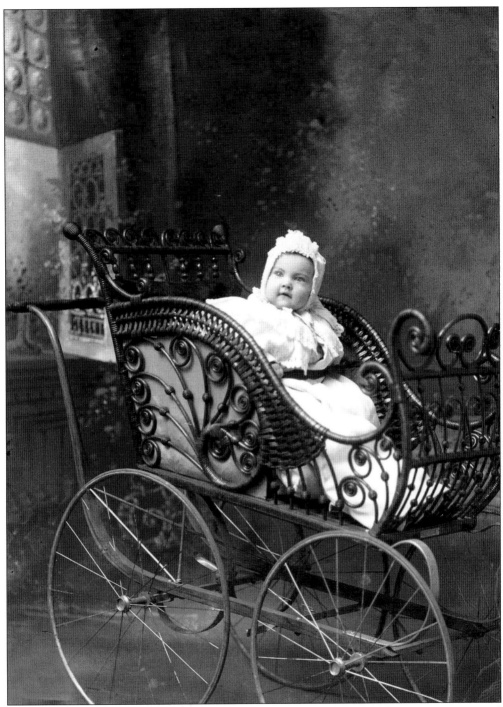

One-year-old Mary Davenport, born in December 1898 to Frank and Martha Davenport, is posed in a wicker pram of ornate detail and typical of a Victorian-era baby buggy. The cost for such a pram in 1897 would have been about $10.50. Mary is dressed in a long white dress and matching cap trimmed with lace and ruffles. Little girls learned at a young age to dress like a lady.

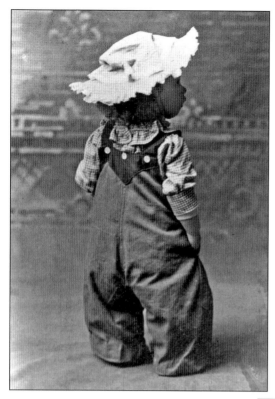

This unique 1900 pose of three-year-old Henrietta Gould was likely inspired by storybook fashions for children. The comic strip character "Buster Brown" was also having an impact on what children wore at the time. Henrietta's little hat adds a fairy tale look. Her parents were George and Ella Gould of Bellwood (see page 41).

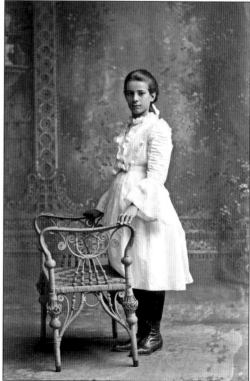

Elizabeth VanLom was about eight years old in this 1900 portrait. The sleeves on her dress are very unusual, while her legs were covered with dark cotton stockings. (Both girls and boys then covered their legs.) Elizabeth graduated from David City High School in 1910 and later married Jay Rising (see page 50). They had two daughters. Elizabeth died in 1919, possibly a victim of the worldwide Spanish influenza pandemic that killed thousands.

Eugene Doty was photographed wearing the ever-popular sailor suit with short pants and long dark stockings. His long hair in ringlets was not unusual to see on boys in 1900. Eugene's parents were Ira and Adelia Doty. Eugene later worked as a life insurance salesman and died in California in 1947.

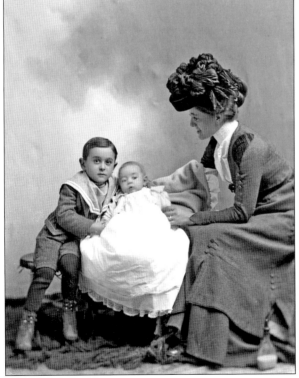

The joy of a growing family comes through in this photograph of Daisy Bauer and her four-year-old son Emmett doting over one of Emmett's younger brothers in late 1900. Emmett's father, Melvin Bauer, was a bank cashier in David City. Note the baby bottle in the picture. This happy scene would be marred by tragedy when Emmett died six years later at Sioux City, Iowa. He is buried in the David City Cemetery.

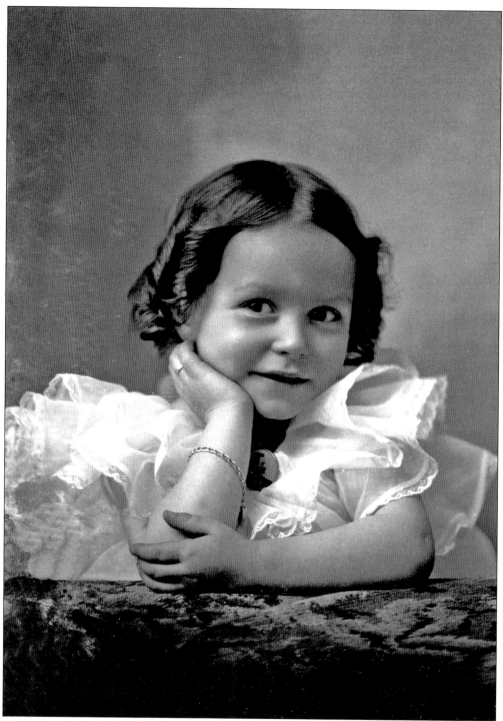

Photographed in 1900 at about age four, Jean Buchta of David City looks like a dream in a sheer lawn dress with the large ruffled neckline. Jean was the daughter of William and Elsie Buchta. Girls as well as women loved to wear jewelry, evident with Jean's pin, bracelet, and ring. She would appear to be daddy's little girl.

Who can resist a naked baby? Harvey L. Boston had a knack for capturing the perfect pose. The infant in this 1901 photograph is Ray Rominger, son of James and Emma Rominger. Ray later moved to Colorado where he worked as a salesman for a drug company.

Marion (left) and Merle Patterson are wearing homespun clothing that was very typical of 1901—dressy but practical for play. They were the sons of Henry and Lula Patterson of David City. They were born about a year apart, Marion in June 1898 and Merle in July 1899. Fate would intervene in that Marion died in 1909 while Merle lived until 1971.

Arnold Roberts was born in Missouri where his father was a traveling salesman. However, the family appears to have been living in David City by 1902, where Arnold Roberts was photographed at age two. His coveralls were called Brownie overalls and cost 25¢ through the Montgomery Ward catalog. Roberts's checked shirt and straw hat were perfect for outdoor play with his wagon.

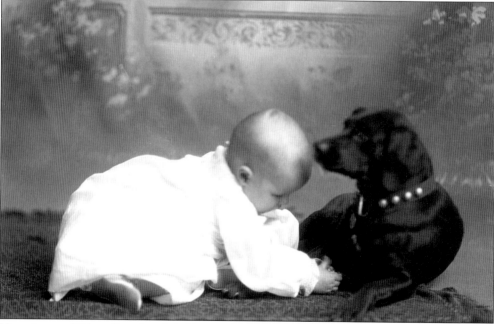

Victorians and Edwardians loved children and animals. Harvey L. Boston catered to this interest in his posings. The backdrop gives an outdoor feel to this 1906 photograph of one-year-old Edwin Lyndon "Ned" May Jr. and the beloved family dog. According to the 1910 census, May's father was a traveling salesman and his grandparents ran a hotel in David City.

Children and flowers were popular pictures for Victorians and Edwardians. Two-year-old Olivee Milner is angelic looking in this 1902 pose. Milner's father farmed in Butler County when the picture was taken. However, the family later moved to Canton, Ohio, where the father was proprietor of a cigar store. Milner apparently lived most of her life in Canton.

Marion Scofield, in 1906, is photographed wearing a tunic-style suit that was more practical for play. The belt added detail, not function. Large bows for boys were still a fashion statement carried over from the Victorian era. White shoes and stockings were fashionable for spring and summer. Marion's father, Jesse Scofield, was a railroad station agent.

Marjorie Culbertson Bell was born and raised in David City but moved with her parents to Lincoln some time before 1920. Left as evidence of her life here is this beautiful 1906 picture of three-year-old Bell in her petticoat and stockings. Again, this is an angelic pose for a little girl, with ringlets and bows and a touch of jewelry. Her expression tells all.

Two-year-old Eleanor Gates is in an outdoor setting perfect for her white dress and parasol. Horizontal tucks were functional in children's clothing. As the child grew, the dress could be let down. Eleanor's parasol, in 1907, would have cost about 80¢. She was one of three children born to Frank and Jennie Gates.

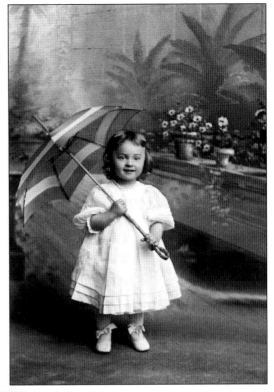

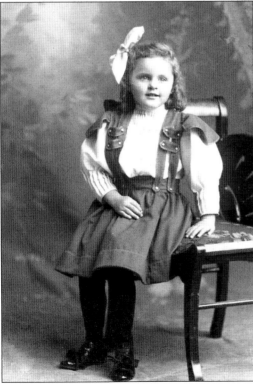

Dorothy P. Van Dyke was born in Octavia on the Fourth of July in 1904. Her parents, Lamber and Jenny Van Dyke, took Dorothy to the Boston Studio in 1908 for this portrait of her wearing an early version of a jumper for young girls. Her white shirtwaist has pleating around the neck and sleeves. A large bow completes the look. Note that her shoes are tied in a different way. By 1910, Dorothy's family was living in Adair, Iowa.

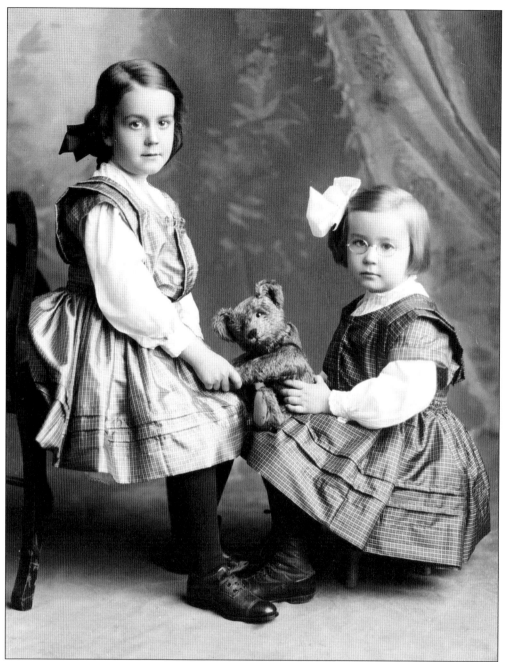

Lamone Nelson, age 7, and Beaulah Nelson, age 4, were sisters in look-alike outfits. Jumpers were all the rage by 1908 for young girls to wear, practical and easy to make. The two sisters otherwise share a stuffed teddy bear. Its name reportedly derived from Pres. Theodore Roosevelt's refusal to shoot a trapped bear cub while on a hunting trip.

The bond between a mother, Pearl McIntosh, and her young daughter, Minnie, comes across in this 1908 view. Pearl wears an elaborate battenberg lace and satin dress, with the high collar and full front. The detail given the bodice top is like icing on a wedding cake. Her hair is in the elegant coiffure hairstyle of the day. In 1925, Minnie would marry Dale Nichols, a David City native who became a nationally known artist and painter.

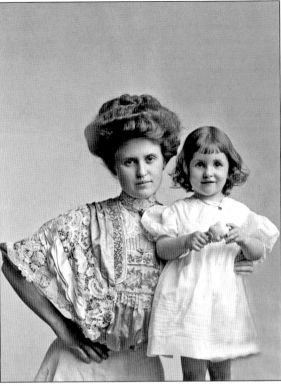

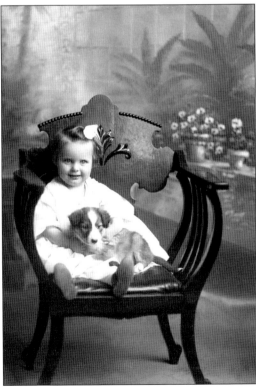

Harvey L. Boston used a floral setting in a number of his children's pictures, and it is a perfect backdrop for Agnes Birkel in her white dress and matching hair bow. The puppy completes the picture. At 19 months of age in June 1908, Agnes was the daughter of Frank and Anna Birkel. In 1932, Agnes would marry Stanley Coufal, who was a partner with Alfred Birkel in a longtime John Deere tractor and implement dealership in David City.

By 1908, bonnets for young girls had become larger in order to resemble the large hats women were then wearing. Such was the case for Olivia Etting, daughter of Alexander and Anna Etting. Her beautiful white dress was advertised in sales catalogs as low priced. The more detail, the more cost.

Harvey L. Boston's business ledger for 1908 indicated this was the family of Anton Wilger from rural David City. While further information on the family is uncertain, it is obvious from the photograph that the girls have on matching homemade dresses. Their dolls are the same but have different hair color to match each of the girl's hair. The boys have handkerchiefs in the front pocket. It is likely that their father did the same thing.

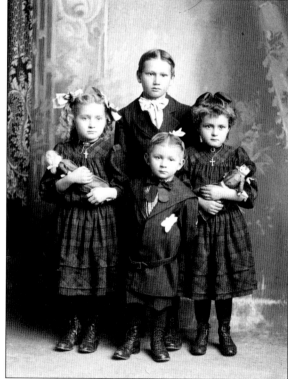

Ida (left) and Harold Hilger were the two oldest children of Victor and Mary Hilger of David City. The garden setting in this 1908 photograph works well with the white eyelet dresses the children are wearing. Ida later taught in a rural school, worked as a secretary in Omaha for 25 years, and then returned to David City and worked at several local businesses. She never married and had no children. Harold would later farm, marry, and raise three children.

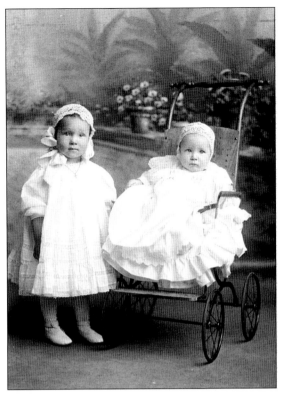

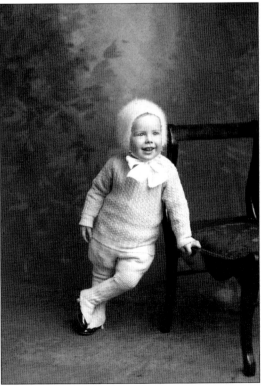

Two years after his first photograph was taken at the Boston Studio (page 86), Edwin Lyndon "Ned" May Jr. was photographed again in 1908. His grandparents ran a hotel in David City. His parents, following their marriage, moved to Beatrice, Nebraska, where they also ran a hotel.

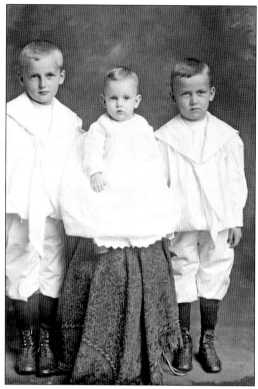

White was worn in summer. In 1909, this included boys such as (from left to right) David, Charles, and Arthur Myers of David City. White sailor suits, as well as being cool for summer, were affordable and easy to launder. The two older boys, David and Arthur, went on to careers with the Chicago, Burlington and Quincy Railroad. They served as chief clerks for the railroad in McCook and Denver, respectively.

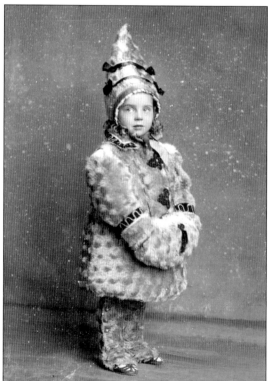

Two-and-a-half-year-old Gloria Dworak was one lucky little girl, what with her matching fur coat, hat, muff, and leggings. As well as warm, this would have been a very expensive outfit for 1909. Her tall hat resembles the large hats then popular with ladies. The specks on the image may have been an attempt by Harvey L. Boston to simulate snow since the photograph was taken inside the studio during May.

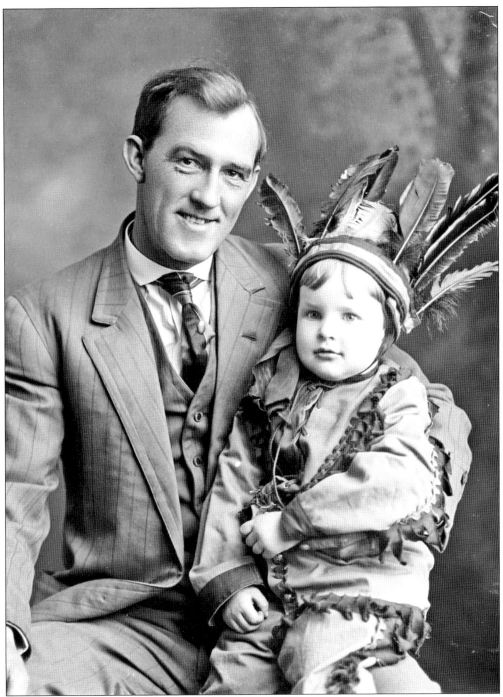

Glen Rominger of David City poses with an unidentified child wearing a Native American costume in 1910. Rominger had a varied career that included being a farmer, traveling salesman for a medicine company, and real estate salesman. With the Wild West shows of the period, costumes like this became popular for little boys to play dress up. *McCall's Magazine* for January 1907 advertised patterns for such costumes for 10¢ to 15¢.

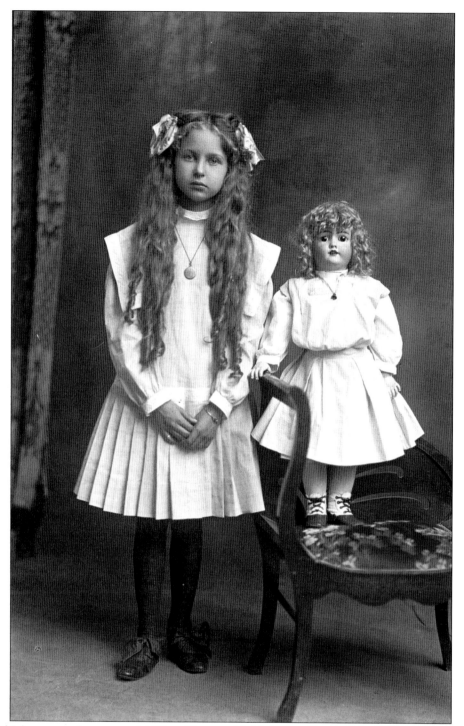

Enid Johnson was born around 1901 to Elmer and Lil Johnson. Her father was a section foreman with the railroad. Enid is pictured wearing the latest in young girls' fashion for 1910, with a drop waist and knife pleats. She and her doll are dressed very similar, from the full head of long hair to the matching locket necklace. Having a full-sized doll would have been the envy of many little girls.

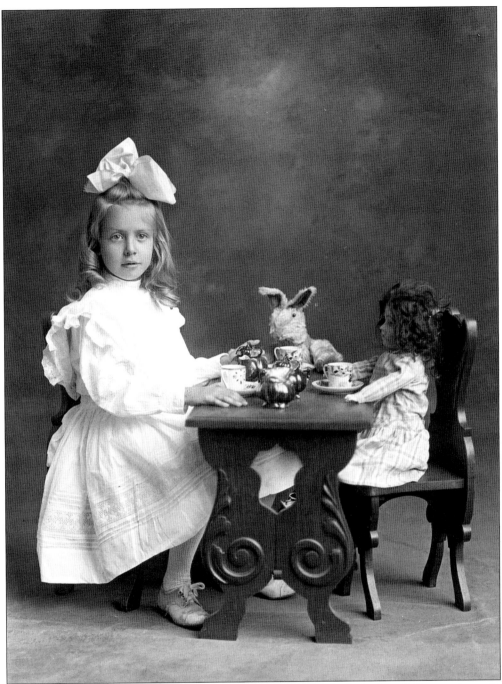

The child's tea set and dolls used by seven-year-old Dorothy Rich for her 1910 portrait would be considered collectibles today. Little girls like Dorothy were then dressed like their mothers, imitating the loose hairstyle and large bows. The white, loose-fitting pigeon-front top with the high neckline would have cost about 60¢. Dorothy's father was Dr. Riley G. Rich, a David City physician.

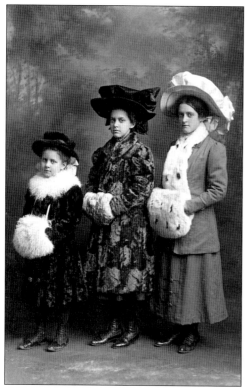

By 1910, hats for women had reached their largest size ever, and these three sisters were right in style with their headpieces. Georgia, Zora, and Zilla Wunderlich (from left to right) were the daughters of a David City livestock dealer. Skirt lengths were then shorter for the younger set, but the styles still resembled the current ladies' fashions. Georgia's matching fur set would have then cost around $2.50.

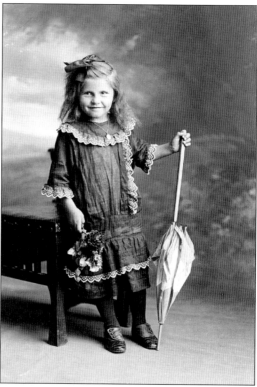

Elinor Rech's drop-waist dress, high-button shoes, and fashion statement parasol were still popular at the time of her 1915 portrait. Elinor's father died shortly after this photograph was taken, leaving her mother, Albina, to raise her and her younger brother alone. The 1920 and 1930 census lists Albina as a widow, working for private families. In 1930, Elinor was 19 years old, still living with her mother and selling dry goods.

Six

MEN, COUPLES, AND FAMILIES

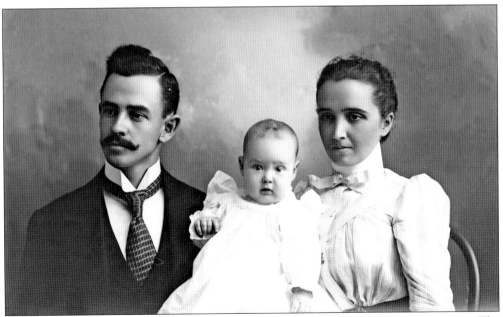

The Robert Munn family, for a family portrait in 1900, are dressed for a new century. The mother, Maude Munn, wears clothes that reflect the Gibson girl silhouette popular at the time. (A famous artist of the period, Charles Dana Gibson drew fashion plates featuring the "all-American girl" wearing a highly starched shirt with a bow tie and dark skirt.) The Munns' daughter, Nadine, is wearing a standard white cotton dress.

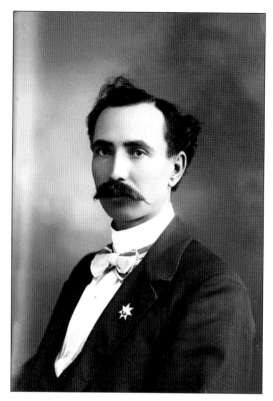

Men's clothing styles, such as the outfit worn by Harvey Davis in 1900, did not change from season to season like those of women. Here Davis's shirt consists of a stiff and high collar that was detachable, along with a small bow tie. A full mustache was popular for men in the early 1900s, as was a side part of the hair.

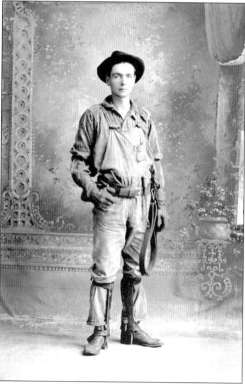

While many people chose to wear their most fashionable clothes for a Boston Studio sitting, William King of David City opted for everyday work clothes in this 1902 image. Listed as a soldier in the 1900 census, King was managing an automobile garage in David City by 1910. He and his wife, Marie, later moved to San Diego, where he worked as a lineman for a street railway company.

Albert H. McDonald of David City was about 31 years old when this photograph was taken in 1902. According to census records, he lived with his parents, was single, and his occupation was never listed. Nevertheless, McDonald's portrait leaves an impression of a man who cut a dashing figure when wearing business attire that included a homburg hat. Topcoats like McDonald's then cost about $10.

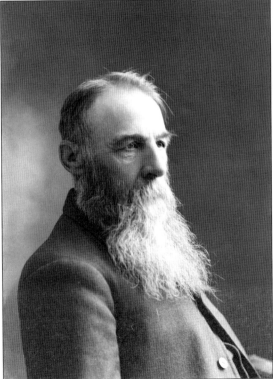

Frank E. Viall is sporting a full beard and suit, as often seen in studio portraits of older men at the start of the 20th century. A native of Vermont, Viall is 69 years old in this 1902 image. Aging parents then routinely lived with their children, and Viall is recorded in the 1900 census as living with his daughter and son-in-law, William and Etta Bell, in Oak Creek Township. The 1910 census shows Viall was still living with Etta, but they had moved to Colorado.

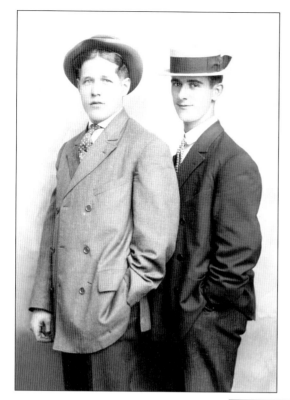

Claude Frater (right) and Archie Gates are seemingly carefree young men in this nonchalant pose from 1906. Typical dress clothes for young men of the era were three-button double-breasted suit coats. Hair parted down the middle and the straw boater hat completed the casual look for summer. This photograph may have been a souvenir of their friendship. Their careers later took Frater to Alaska and Gates to California.

Full-length fur coats like the one worn by Jerry Allen in 1906 were both fashionable and practical for cold Nebraska weather. Fedora hats were worn with this style of coat. According to the 1910 census, Allen was living with his wife and son in Bone Creek Township where he farmed.

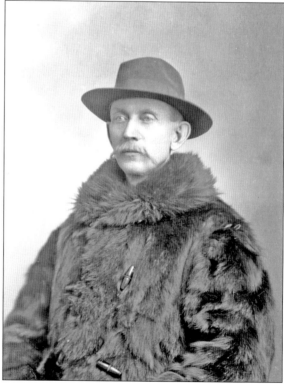

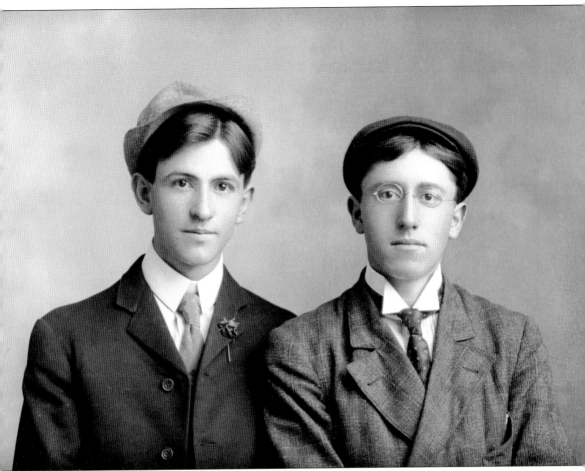

Two young David City men, Grover Eberly (right) and George Zunibel, show that hats were just as important to men as to women in 1906. Certain hats went with certain outfits, in this case with starched collars and suits. Eberly later became a druggist and operated a drugstore in Sheridan County in Nebraska for several decades. Little information is readily available on Zunibel.

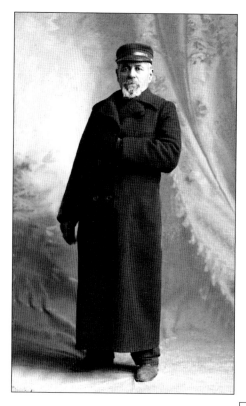

This photograph of John R. Jones is listed in Harvey L. Boston's business ledgers as being taken on Christmas Day, 1907. It shows Jones wearing a winter yacht-style cap and long wool coat. The latter was stylish as well as warm. It likely came in handy for his occupation. The 1880 and 1900 census lists Jones as a drayman living in David City. Using a horse-drawn wagon, he made deliveries around town of either freight shipments or large pieces of baggage that had arrived aboard trains at the three local railroad stations.

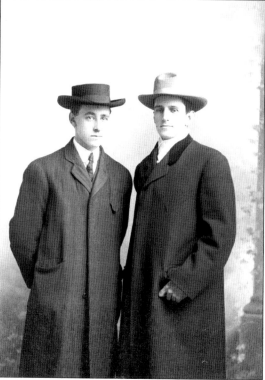

The early automobile age had an impact on men's fashions, as seen in this 1907 view of Henry Cram (left) and John Ayres. Both were fashionable in their automobile coats and Stetson hats. (Either style of hat could then be bought for $3.50.) Cram followed his father's occupation and became a real estate agent in Butler County. Ayres moved to Osceola in Polk County, where by 1917 he was listed as being an optometrist.

This 1908 photograph makes the author think of Pres. Teddy Roosevelt. It actually shows Butler County farmer George Aldrich. Harvey L. Boston knew just how to get the right look using the different props and backdrops to capture the subject's personality. Aldrich's solid gold eyeglasses, without the chain, would then have cost about $3.

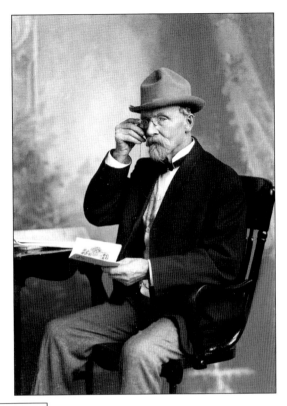

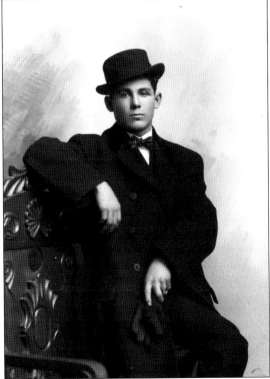

Arnold Crow appears to have been a man with fashion sense, flair, and impeccable taste. He is pictured wearing a typical daytime attire for 1908, topped off with a derby hat. (In England at the time these were called bowler hats.) Crow's family had moved to David City some time prior to the 1910 census, where he was bookkeeper at a bank.

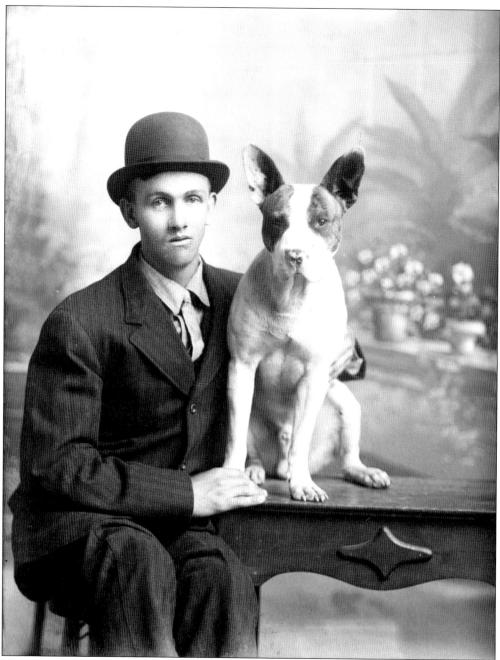

Harvey L. Boston demonstrates his skill at photographing animals with their owners in this 1908 view of Lucien Fuller and his dog. Fuller is wearing the sack suit and bowler hat typical of the era. He had moved to David City prior to the 1910 census, where he was listed as an attorney. By 1920, Fuller and his family had moved to Omaha, where he was vice president of the Guaranty and Securities State Bank.

Jacob L. Davisson graduated from David City High School in 1909, this photograph having been taken that August. Like other young men of his time, Davisson went with a casual pose while wearing a two-piece suit with cuffed slacks. The straw boater hat was for a more relaxed look for picnics and outdoor summer activities. By 1920, Davisson had a family and farmed in Missouri.

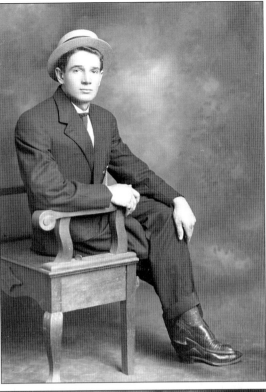

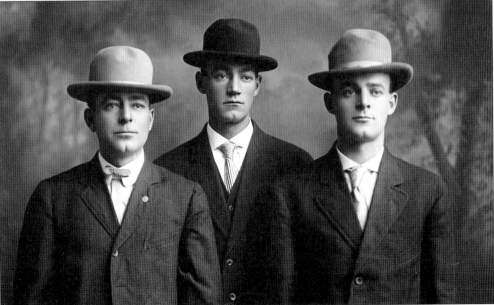

Logan and Charles Spelts, brothers originally from Ulysses, were photographed with Louis Spelts (possibly a cousin) in December 1910. These young men, in their 20s and apparently all married at the time, found livelihoods away from Butler County. (Logan and Charles lived in Colorado.) Perhaps a family reunion at Christmastime provided occasion to visit the Boston Studio for a portrait. The three are topped off with then-popular Stetson hats, which could be purchased dented or not.

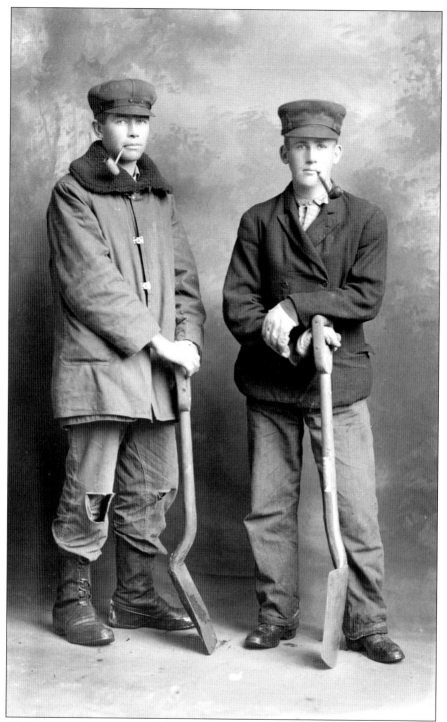

Harvey L. Boston took a variety of photographs ranging from a formal wedding to a cute baby. However, this 1909 photograph of John Lawver and Guy Powell in old work clothes and armed with shovels may have been an occasion to have some fun. Note that their pose is complete with a corncob pipe.

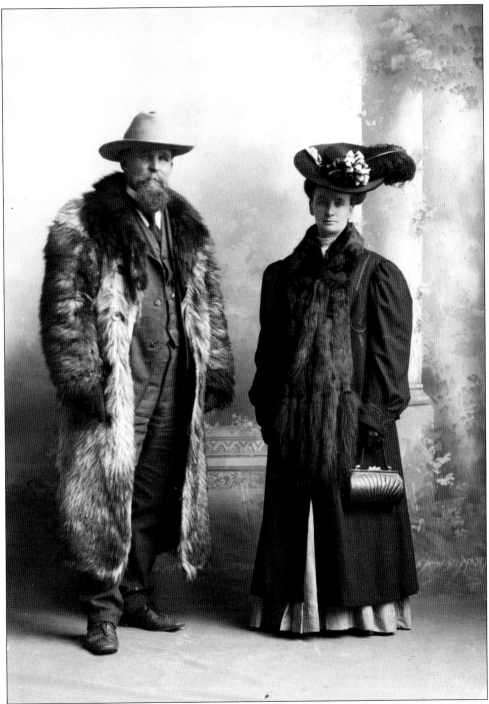

What is believed to be the wedding picture for Orrin and Tinnie (Van Matre) Thayer was taken at Boston Studio in December 1906 following their marriage that month in Schuyler. Orrin is wearing a fur automobile coat, along with his high-fashion Stetson hat. Tinnie also has on a long wool automobile coat with a popular fur collar that added style in addition to warmth. Alligator traveling bags were then both stylish and practical.

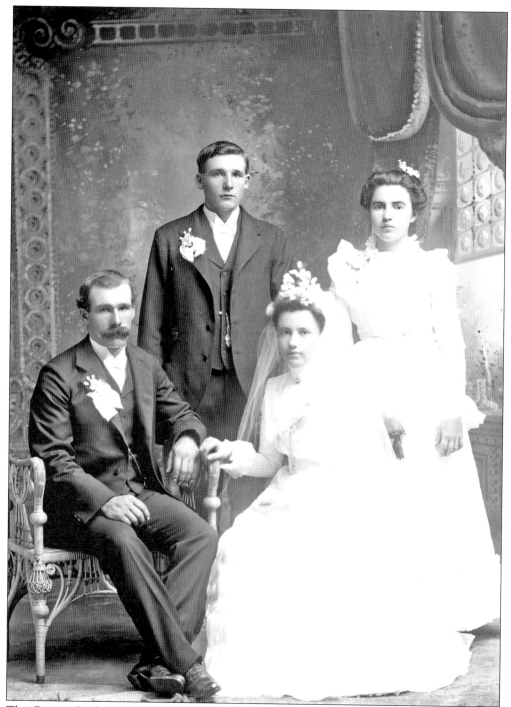

This Boston Studio scene of Nick and Margaret (Meysenburg) Remakel is recorded as having been taken on their actual wedding day, October 30, 1900. This image not only shows the bride and groom but also the best man and maid of honor in the same type of dress. The difference with the bride is her beautiful large veil. Again, the suits and white dresses were so versatile that they were often worn for different occasions after the wedding.

This wedding photograph of Edward and Rose (Kovar) Dostal was taken at the Boston Studio about a month after the couple's wedding in the Assumption Catholic Church at Appleton on October 4, 1904. Note that wedding veils followed the style of women's hats at the time, the larger the better. Appleton was a small church, school, and social hall community located west of Bruno. Edward and Rose raised five children near Appleton. They are now buried in the cemetery alongside the church where they were married.

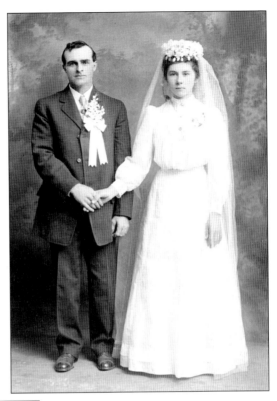

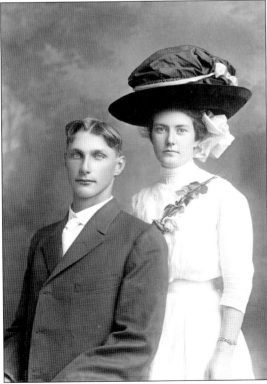

This photograph of Lee and Jennie (McCoy) Woolsey appears to have been taken in David City on their wedding day, October 5, 1910. Women then not only wore large hats but added large bows as well. Several yards of material were used to decorate these hats, with an obligatory number of large hatpins used to hold them on. Note that three-quarter-length sleeves were then in vogue for adding long gloves. The Woolseys farmed in Sherman County in Nebraska and raised five children.

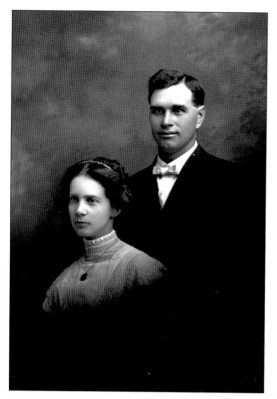

This is believed to be either the wedding or engagement picture of Carl and Anna (Litjen) Geiger. They were the second couple to be married in the newly completed St. Mary's Catholic Church in David City on September 17, 1912. Carl farmed near Ulysses, where they lived and raised three children. Regarding Anna's beautiful lace dress, many collars like this would have a small wire sewn underneath to hold the collar up.

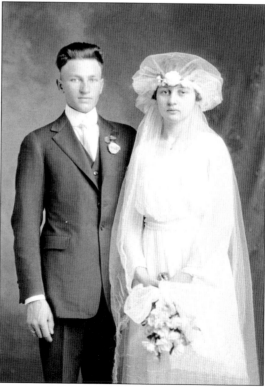

The 1920 wedding photograph of Ervin and Phoebe Hinze of Rising City shows the then-changing style of marital fashions. Ervin's suit jacket is more fitted, while his hair is slicked back and trimmed on the sides in military styling. Phoebe's large cloche headpiece was the look of the 1920s. Wedding dresses were made of fine lace net very similar to the veil, with a satin underslip. Matching engagement and wedding bands appeared during this decade.

Pride in their Bohemian and Moravian ancestry shows in this photograph of the Frank Sedlak family, who farmed in Franklin Township. Frank's suit is typical attire for a man in the late 1890s, complete with a Homburg hat. His wife, Anna, is dressed in her best outfit accented with a ruffle yoke. Her eyelet apron with a scalloped edge was made to receive guests, a true work of art. One daughter, Mary, has a beautiful detailed bodice with wide lace. The other daughter, Agnes, has some lace accent around the neck.

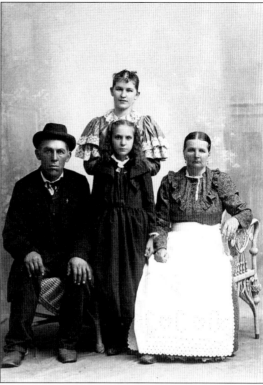

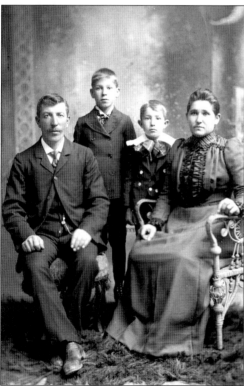

The Charles Kuhl family of David City was an example of the many German immigrants who came to Butler County for a new start. Charles Kuhl had emigrated here from Germany in 1882. His wife, Sadie, came the following year. They are photographed with their two sons, Frantz (Frank) and Otto, in 1900.

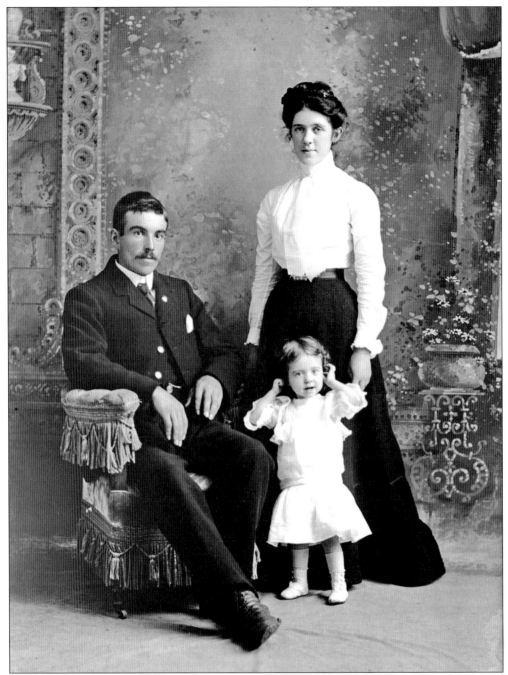

The George McGaffin family of Bellwood was part of the large McGaffin family of Irish descent that made its mark in the newspaper and print business. George's father was longtime Bellwood newspaperman William McGaffin (see page 37). George, born in Ireland, apparently remained there after other family members had immigrated to Butler County. He married Mary Brown in Ireland in 1900. After their oldest child, Marjorie, was born in the Emerald Isle, the family followed the other McGaffins to America and farmed near Bellwood. This 1902 image commemorates their achievement of the American dream.

Bessie Clark, the wife of James Clark, is pictured with her two sons, Roy (left) and John, in March 1910. All are wearing dark clothing, which more than likely meant they were all made of nonwashable fabrics. The two boys are wearing sailor suits with a low belt that were advertised as a "Russian suit," along with high-top shoes. Bessie is in a ready-made dress with fashionable braid. Her matching headband completes the outfit.

David Siffring was a German immigrant who could tell stories of traveling across Nebraska via covered wagon and living in sod houses. He is pictured here in 1920 with his three youngest sons, out of a total of 10 children. David and his wife, Emma, then owned a farm south of Rising City. The three sons seen here from left to right are David Jr., Chris, and Rudolph. From this photograph, one can see that men's suits have not changed much through the years, although ties are now wider.

Elmore Schweser from Surprise was the only World War I aviator from Butler County. The distinguished veteran poses with his wife, Theresa, and daughter, Virgene, in 1926. The family's fashions are very representative of the 1920s. Theresa wears a drop-waist tubular-style dress and finger-wave bob hair. Virgene has rolled stockings and Mary Jane shoes (not seen). Elmore has the men's hair fashion from the 1920s, center part and plastered down with pomade, giving it a patent leather appearance. Note the backdrop is not as ornate as it would have been in 1900.

Seven

ON LOCATION

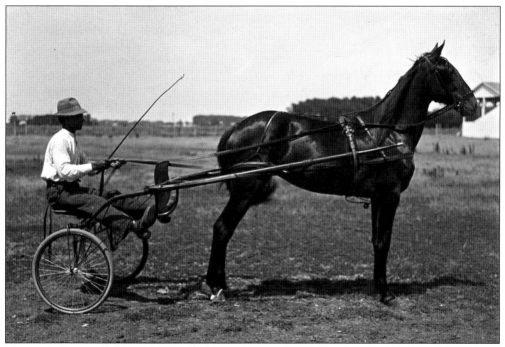

Harvey L. Boston did venture outside his studio to take portraits. One example is this undated shot of William (Billy) Parks, a longtime horse trainer in David City. Parks, an African American originally from North Carolina, was first employed here by H. H. Smith when David City was a horse racing center. Parks was very proficient with horses and lived at the stables at the Butler County Fairgrounds. Here Parks poses with a trotter horse pulling a sulky.

Regrettably, only a few of Harvey L. Boston's scenes of early David City are known to still exist. This one shows the east side of the old courthouse square, around 1900, before the streets were bricked. Since the photograph shows a row of hitched rigs belonging to rural mail carriers and farmers, Boston humorously wrote on it, "David City—A Good Place to Tie Up."

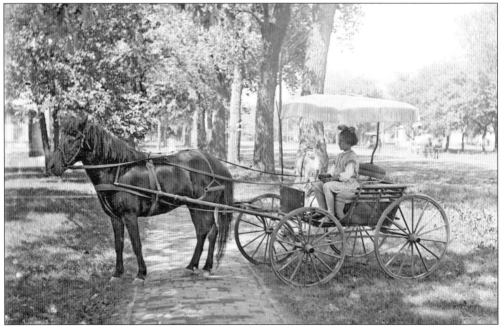

Another horse-drawn vehicle photograph is this July 1910 view of Georgia Wunderlich (see page 98), then about eight years old, with a pony and elaborate carriage in David City. Georgia Wunderlich may have been out for a ride with her pet pony. However, motorized transportation would soon usurp the horse for everyday transportation.

This undated scene was taken at the Burlington Railroad depot in David City. It is possible that the man standing beside the early truck is Glen Rominger (see page 95), who was a traveling salesman for the Baker Medicine Company. A supply of goods for the firm had either just been delivered by train or had been trucked to the depot for rail shipment to customers.

Harvey L. Boston was also hired to take photographs of Butler County farm scenes. Such images may have been used by the farm owner either for insurance purposes or to send to relatives who were at a distance. For this unidentified barnyard scene, Boston apparently found it humorous to imprint, "Give pigs a chance and they'll soon make hogs of themselves." The image was perhaps later made into a real-photo postcard sold at the Boston Studio.

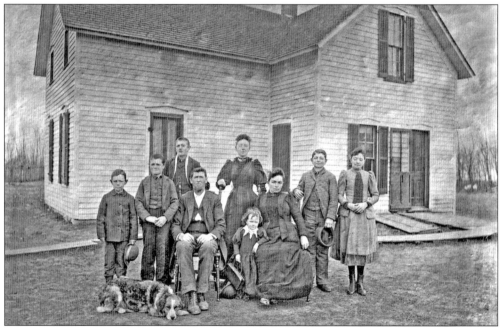

Boston apparently photographed the Michael Delaney family (see page 25) in front of their large, frame farmhouse near David City. It is possible the structure had then recently been completed. Although this scene is undated, the family's clothing appears to be from the late 1890s or early 20th century. The family dog is included in the portrait sitting.

The rise of automobile technology in the early 20th century made cars more affordable to many families. Harvey L. Boston was therefore called upon to record the inevitable result: car accidents. This image, dated September 3, 1926, shows the aftermath of a mishap involving an automobile belonging to Butler County farmer Howard Doty.

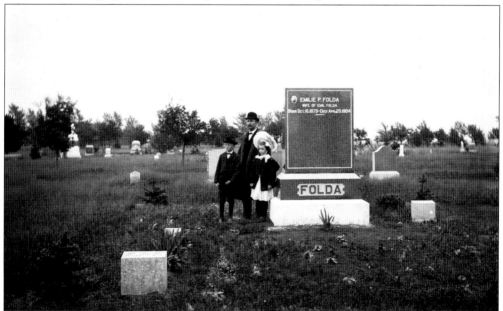

Emil Folda (see page 47), a banker in David City and later Linwood, was left a widower with two young children following the death of his wife, Emille, in April 1904. She was buried in the David City Cemetery. Here, about four months following her death, Emil and his two children, Albin and Laura, are photographed at her grave site. Perhaps her engraved marker had just recently been completed.

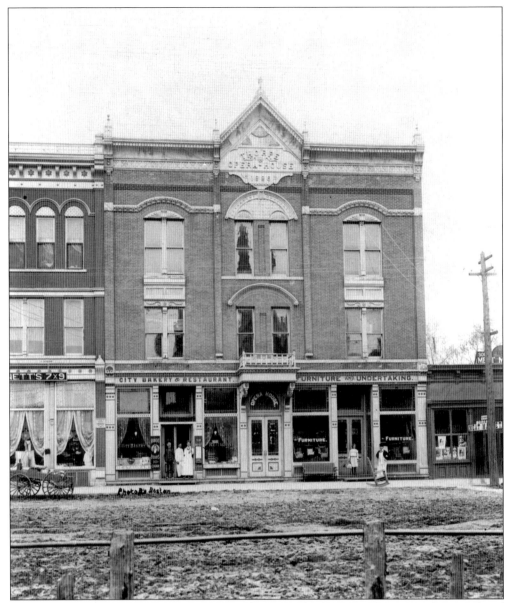

The Thorpe Opera House in downtown David City was built in 1889 by W. B. Thorpe, a local banker, to bring entertainment and enlightenment to the community. Its second-story auditorium was then the largest performing arts facility west of Omaha, seating about 1,000 patrons. Performances on its stage included theatrical productions, political debates, and magic acts. Entry to the opera house was through the stairwell doors located below the small balcony. Many of the persons pictured in this book likely passed through those doors while wearing the costumes depicted in this book.

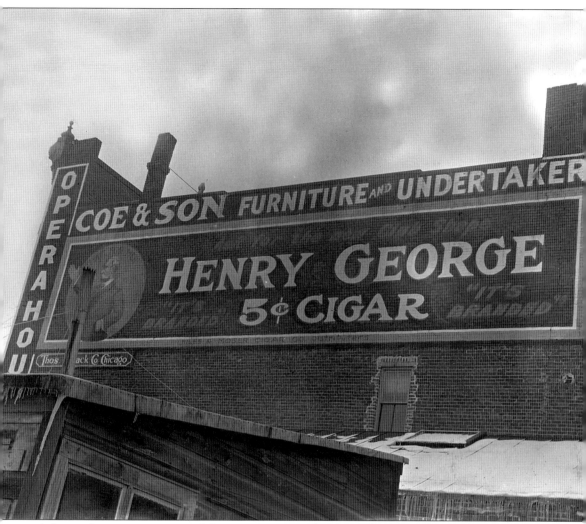

A large advertising sign existed for many years on the west side of the Thorpe Opera House building in David City, visible to passersby on Fourth Street. The products and services being promoted in 1910 were undertaking, furniture, and 5¢ Harvey L. Boston was hired to take this view by Thomas Cusak and Company, then listed as a "patching company" in Omaha. The photograph is probably of the building either before or after repairs were made. Although local businesses continued to operate on the first floor, the opera house saw only sporadic use after local motion picture theaters were opened. It was eventually forgotten and fell into disrepair. However, the Thorpe Opera House was renovated and reopened for public use in the early 1980s. Its historic charm and ambiance is now appreciated by audiences and performers alike.

During the Victorian and Edwardian eras, it was not unusual for Harvey L. Boston to be asked to take pictures of a deceased family member in the casket as a way of remembering a loved one. Sometimes this type of photograph was taken if there were no other images of the deceased or if a close relative could not attend the funeral service. The identity of the deceased and the date of this image are unknown.

This damaged image shows six women who were pallbearers at Viola Graham's funeral in David City during August 1894. Note the homemade ribbons on the arms of the women, meant to be seen. The women on the right are wearing maternity dresses. The circumstances regarding the death of 19-year-old Viola Graham are not known.

Harvey L. Boston occasionally used his talent to take photographs where animals were the main subject. In addition to his family (see page 25), David City banker Thomas Wolfe had a photograph taken of his pet cat Buster. Perhaps Buster was employed as a mouser in Wolfe's office at the First National Bank of David City.

In 1901, Boston was able to capture the playful nature of two dogs owned by Hattie Ren from Bellwood. More is known of their owner. Ren contracted spinal meningitis while attending school in David City, causing her to become deaf. She graduated from an Omaha school for the deaf in 1903 and then entered a college for the deaf in Washington, D.C. Graduating in 1908, Ren accepted a teaching position at a school for the deaf in Sulphur, Oklahoma. She died there in late 1909. A promising life and career was cut short at age 24.

As football was a sport just becoming popular in Nebraska, Harvey L. Boston took this shot of the Bellwood town football team in November 1900. Everyone is clean-shaven, with the exception of the large man in the back row, who is sporting a full mustache and hair parted down the middle. Each man seems to strike his own pose, with one young man even reclining. Uniforms for football have come a long way since then. Pictured are (first row) Bryant Loomis, Lew Speltz, Clifford Slade, and Oscar Brewer; (second row) Ed Grisinger, Jim Dearwister, "Buc" Grisinger, Rennie Yates, and Lem Kegris; (third row) Royal Judevine, Charles Grisinger, Jim Slade, Dr. Martin Sample, Henry Deford, Pete Disney, and Frank Judevine.

The impression given by this 1908 photograph is that the couple, believed to be Henry and Thelma Rathje, is entering their grand new home near Rising City for the first time. Houses of the time were like clothing fashions, detail was very important and a status symbol. The Rathjes were German immigrants who came to the United States in 1884.

A number of images in the Boston Studio collection remain a mystery as to why Harvey L. Boston took a picture of the subject. One example is this 1901 photograph of a tooth taken for Dr. Frank Crie, then a dentist in David City. Dr. Crie originally hailed from Ragged Island in Maine. It is not known how long he practiced in David City.

The most famous photograph taken by Harvey L. Boston was not even made in his studio. This image of a tornado was taken by Boston from an upper room of his house using a simple box camera as the twister bore down on David City on June 16, 1925. The photograph was widely published in newspapers and magazines throughout the United States and in some foreign countries. It was used in at least one textbook.

ACROSS AMERICA, PEOPLE ARE DISCOVERING
SOMETHING WONDERFUL. *THEIR HERITAGE.*

Arcadia Publishing is the leading local history publisher in the United States. With more than 3,000 titles in print and hundreds of new titles released every year, Arcadia has extensive specialized experience chronicling the history of communities and celebrating America's hidden stories, bringing to life the people, places, and events from the past. To discover the history of other communities across the nation, please visit:

www.arcadiapublishing.com

Customized search tools allow you to find regional history books about the town where you grew up, the cities where your friends and family live, the town where your parents met, or even that retirement spot you've been dreaming about.

MAP SEARCH